# Innerview: Lessons in Leadership

The best transformation starts with an "Innerview."

*Mathic Williams*

# Innerview: Lessons in Leadership

Natilie Williams

Nat Will, Speak! LLC

**Innerview: Lessons in Leadership**
Copyright ©2020 Natilie Williams

Published in Chicago, IL, by Preamble Publishing

Nat Will, Speak! LLC
contact@natwillspeak.com
www.natwillspeak.com

This book is nonfiction. It reflects the author's present recollections of experiences over time. While all stories in this book are true, some names and identifying characteristics have been changed to protect privacy.

Bulk Sales
Books are available with special discounts for bulk purchases. For more information, send an email to contact@natwillspeak.com.

Printed in the United States of America First Printing, 2020
ISBN 978-1-7356449-0-5

Editor: Marcia Garnett, Emerald Garnett Editing
Cover and Author Photo: Kat Merriman of KatFour Photo LLC

# Contents

Acknowledgements     iv

Introduction     v

Leadership Isn't a Hobby, It's a Lifestyle     1

     Board of Directors     3

     The Secret Service     5

Losing My Biggest Coach     9

The Marathon Continues     17

Not a Big Ten School, but We Make Big Ten Moves     25

Perspective Makes the Difference     34

Prepare, Perform, Repeat     42

It's Not for You, It's for Me—Forgiveness     47

Behind the Stage Sets the Scene     54

     Shifting Gears and Moving Forward     61

     Evolving     66

Beyoncé Wasn't Built in a Day #SisterhoodGoals     72

Don't Push Me Cause I'm Close to the Edge     80

Timing Makes the Difference     88

It Was All a Dream in a Different World     95

Discipline with the Help of Santa Claus                        106

Community for Survival                                         114

    Counterfeit Mentors                              117

    Experienced Leaders                             120

Even the Big Homie Can Be Wrong                                124

Don't Die, Especially in the Winter                           130

Love Lyfts Us Up                                              139

Some Cycles Aren't Meant to Be Broken                         147

A Return to Say Thank You                                     156

No Is a Complete Sentence                                     164

Set the Pace for the Race                                     172

Allow Me to Reintroduce Myself                                180

# Acknowledgements

Well, the book is finally here. I give God all the glory for allowing this book to be the manifestation of my own progress and healing.

I have to thank my amazing board of directors, who you will hear me talk more about throughout this book. Thank you for wiping my tears, celebrating my achievements, challenging me to be better, laughing with me until we couldn't breathe, and most of all, being my prayer partners. To the Golden Girls, my appreciation for you all is beyond words in the English language.

To my grandmother, thank you for believing in me when I sometimes didn't even believe in myself. You knew when I needed a hug or to let out a cry. You rejoice in my happy times, and you always offer words of wisdom. Your strong faith taught me how to remain faith-filled at an early age, and I love you to pieces for the strong woman you are.

To Auntie Dee Dee, thanks for personifying love and always being present.

To Nate, you are a place of reality, direction, and progress. I cherish you as my dad.

To Cotrina, you were the best mom that a girl could ask for. As you watch from heaven, I pray that I've made you proud.

# Introduction

While traveling the country to speak, I often get a list of great questions related to life and leadership. I've always answered the questions joyfully, but I've also felt like I could've provided so many more details in my answers; unfortunately, time allowed for but so much detail. The desire to provide more is what motivated me to write this book. It was the reason for me to sit still and find my place of reflection.

This book is a physical representation of what happens when you're willing to sort through your past experiences, retrieve the lessons and then share those lessons with the world. These moments of reflection have caused me to have extreme gratitude for full-circle moments that assure me that the highest moments and darkest times were never wasted experiences. The best leaders are those who look inward to their learned wisdom and aren't afraid to use an innerview to do so.

As someone who has committed to living a life of leadership and empowering others, this book is a result of my own innerview. *Innerview: Lessons in Leadership* is my opportunity to provide you with insight on the biggest lessons I've learned from my life and leadership. These lessons have shaped the very essence of how I walk in purpose and show up as a leader to impact the lives of others. However, this book is not just about my experiences. I've included moments of reflection with the hopes that you'll be motivated to reflect on your own experiences. and I've provided some questions for you to conduct your own innerview.

So, here it goes...

# Leadership Isn't a Hobby, It's a Lifestyle

"There's a level of clarity we achieve from innerviews that we can't find anywhere else."

A lifestyle of leadership isn't about short, temporary instances of leading others; it's about making our spaces and communities better by committing to change the lives of others. This type of forward-movement leadership creates and leaves a legacy beyond ourselves for others to pick up and continue the work that we've started. People with strong legacies inspire others to do real work and change real lives, but great legacies don't just happen overnight. Legacy work is the product of introspection and innerviews that help you to recognize where the most change and impact can happen.

We are all pretty familiar with an i-n-t-e-r-v-i-e-w because it's the last place before the finish line for our dream job. It's the time spent answering questions with half-truths. It's this overconfidence in knowing that we dressed up the truth enough to move beyond a prospective employee to a certified employee. However, an i-n-n-e-r-v-i-e-w is different from the interview because it's where we self-assess

with a sense of honesty that purges our urge to defend or hide any potentially negative personal characteristics. More importantly, the innerview gives us time to just be honest with ourselves and translate that honesty over to others. There's a level of clarity we achieve from innerviews that we can't find anywhere else. But there's a process to have a successful innerview, just as there is a process to have a successful interview. When we innerview, there is no fancy room with an interviewer sizing us up to see if we're good enough for the job. We hold two roles in the innerview: we are the innerviewee and the innerviewer. We become the judge and the jury. We create our own questions, and we provide ourselves with the answers. It may initially sound like a contradiction, but the value in the innerview is that we won't lie to ourselves. At least, we shouldn't lie to ourselves.

Innerviews are the purest forms of self-awareness. When discussing innerviews, I love to use the opposite, interview, as an example. In an interview for our dream job (making the salary we desire plus more and with all the benefits we enjoy), we are often tempted to extend the truth. It's like when the interviewer asks if we are proficient in Microsoft Excel, and we respond that we've pretty much created the software knowing that our response couldn't be any further from the truth. However, in an innerview, we answer that question honestly and make it clear that we have plenty of room for growth with developing Excel skills; we are coachable. But some of our best interviews aren't the times when we use desperation or a colorful description; instead, the most valuable interviews are when we have the epiphany of where we can improve personally and professionally, whether we get the job or not.

Every now and then, we have to make time for self-reflection and seeking direction. It's the same as when you're dating someone, and you both really like each other and even see a future together. At some point during the dating phase, you may ask them the infamous dating question: "So what are we doing?" What you're essentially asking them is, "Where are we going with this relationship?" The answer to that question tells you a whole lot. It allows you to know how to operate within the relationship going forward, and it also provides insight on the other person's intentions. Things shift based on the intentions of relationships.

Our legacy-building leadership is no different than building a romantic relationship in this context. More times than not, we have to slow down our pace of living it up in life and make sure we are leading with intentionality. We have to sit back and ask ourselves, "So what are we doing?" and "Where do we see this going?" Leadership requires that we know how to direct our academic, personal, professional, and spiritual selves within the confines of our purpose and our calling. If we aren't sure of our purpose and calling, an innerview is a sure way to unpack the gifts that we have. Higher-level innerviews are often sparked by conversations that drip with wisdom and clarity. This higher-level innerview can even take place in transparent conversations with our board of directors.

## Board of Directors

Most successful and lucrative companies create and cultivate a board of directors, all of which hopefully have diverse backgrounds. These members each have a specialized role and interest in ensuring the well-being of the company. They each understand their role, and very rarely do they try and compete with each

other since they're on the same team. For each company goal, whether short term or long term, the board of directors has a hand in the success of the company. We all need our own board of directors. Our board should be made up of mentors who provide that spiritual, academic, personal, and professional advice we all need at various points in our lives.

Who makes up your board of directors? You may not have a Chief Diversity Officer, but you definitely need a Chief Spiritual Officer or Chief Voice of Reason. This relationship includes a pure form of trust, which is imperative because your future is at stake. You are allowing this team to have access to some of the most sacred parts of you as a human: your mind, heart, and ears. Think back to a time when you were unsure of what decision to make and you called up a trusted friend to explain your dilemma, and that friend provided you with advice that you went with. You, of course, made the decision, but you relied on the advice provided to you because you deemed your friend to be credible and have your best interest at heart. Now consider how differently the outcome could have been if that trusted friend intentionally provided you with ill advice because of purposefully bad intentions.

Board of directors have power, probably more power than what they may believe. Nonetheless, when collecting your board of directors, figuratively review their applications of what all they bring to the table and how they can assist you with bringing your goals, leadership skills, and personal development to the next level.

# The Secret Service

Beyond having a board of directors, we also need to have our own secret service. Yes, the same group that is notorious for protecting presidents. In the spirit of transparency and authenticity, I am madly in love with the secret service. It's the kind of love that makes your heart flutter, your eyes gloss over, and your smile widen. This is a true love.

I've seen one too many documentaries on the secret service. What I love about them is that they plan with immense detail, and they have a contingency plan for almost every step. These agents are trained and ready to take a bullet for any president, if need be. They have their job of providing protection so that the president only has to worry about presidential duties instead of personal safety. Whenever a president is going to visit a specific venue or location, the secret service goes to that location weeks or months in advance to scope out the layout. They actually retrieve blueprints of not just the venue that the president will be visiting but also of surrounding venues. They then put parameters in place to ensure that no person gets too close to the president in fear of any physical harm.

In the context of leadership, our board of directors and secret service are people who are invested in seeing us grow. Our personal secret service understands our value so much so that they are willing to protect and cover us as we grow as leaders. They are the positive mentors who help us understand the power of our actions and consequences; they are the people who sometimes believe in us more than we believe in ourselves because of their perspective of our abilities. True effective leadership doesn't take place without an innerview at some point in our

lives or without the help of a committed board of directors and a team of loyal and willing secret service members.

# Innerview Questions

Who is on your board of directors?

Who are your secret service members?

# Losing My Biggest Coach

"If life is a boxing match, then overcoming life's most traumatic and difficult situations is not about just parading around the boxing ring in unhealthy pride. It's about showing the power of not quitting, televising your training sessions, being knocked down in the fight, taking breaks during training, and still coming out victorious."

Whenever I think of marathon runners, sports players, or notable athletes, I focus more on the process that it takes to win and complete a race or game instead of the medal or championship ring. The geek in me wants to know the impact of the trainer and coach on the athlete's success and the hours of work and discipline it took for the athlete to embody being a winner. The trainers and the coaches are the ones who have the years of experience and the perspective that the athlete doesn't have, but the trainer and coaches share it freely and in intentional increments. The greatest coaches aren't the ones who bash or insult the athletes into greatness; instead, it's the coach who gives directions with love and the vision of seeing an athlete win. It's the coach who intentionally learns the athlete's weakest areas and strongest parts. The coach who then designs a training

plan with the purpose of exercising those weak parts to ensure they are weak no more and making the strong parts even stronger, thus producing an athlete who is now ready to win the race or game.

I had the best coach that anyone could ever ask for, and instead of training me for a sport, she was training me for the marathon called life. My coach was my mom, who was affectionately known as Trina to others but mommy to my brother and me. She was about 5'7" with a caramel complexion, a distinct voice with a tad of rasp, and a soothing hug that could turn devastation into the most peaceful atmosphere. I was 13 years old when my mom passed away, and I still remember that day of her death as if it was yesterday.

One Sunday morning on August 6, 2006, while getting ready for church, my mom complained about not feeling well, and things immediately took a turn for the worse. She requested that I call 911 because she was having pain in her chest. She described it as an extreme pain that she had never quite felt before. Unbeknownst to us at the time, she was having a heart attack. Even at 13, I knew that having chest pains was an emergency situation, and I couldn't afford to panic or freeze. As much as I wanted to take about five seconds to breathe deeply and pray it was all a dream, I couldn't. I quickly grabbed the phone and dialed 911 as she had commanded. I also had to wake up my brother and let him know that our mom needed our help. In that moment, I felt as if I was having an out-of-body experience, watching everything happen in slow motion with no time to panic.

I remember calling my grandmother and telling her to get to our house quickly, trying to explain the situation as best as I could. Any other day, it would have normally taken my grandmother roughly 25 minutes to drive to our house.

That day, she arrived after the paramedics, and it took her no more than 15 minutes flat. My mom unresponsive when the paramedics arrived, and I felt numb as I watched the EMTs attempt to revive her as she laid on the living room floor. I wasn't overtly hysterical; I just knew at that moment that my life would never be the same, and I was correct.

For some reason, my memory blanks out on how I got from the house to the hospital; I just know I didn't ride in the ambulance. Trauma seems to do that at times; it blocks out harsh memories as a protective mechanism. I remember being at the hospital waiting around to get an official word on my mom's condition. By that time, most of my family had come to the hospital, and we all waited in a room that had maroon-colored walls. At some point, my grandmother and my aunt had walked out of a set of double doors holding each other up with looks of pure anguish, pain, and bewilderment. They both stumbled out shaking their heads as if to say "No." I knew this meant that my mom hadn't survived that random and unexplained heart attack. In that moment, I felt as if my heart had been ripped out of my chest. My stomach was in knots, and the railing next to me became the only reason I didn't pass out or hit the floor. I repeatedly asked, "How?" and "Why?" This couldn't be happening to me. There was no way that I could spend the rest of my life without my cheerleader, best friend, and role model.

Well, my worst nightmare came true that day, and it's something that I live with daily. Even as an adult, I frequently feel the urge to call my mom, and it's not until the phone is in my hand that I realize that I can't call her. I can't rant about how hard it is to pursue a PhD. I can't tell her about the love of my life or a heartbreak. I can't tell her how fulfilling my speaking career is or even share my

quirky rituals that I have before I take the stage to speak. The birthdays, graduations, and family holidays aren't the same because of her physical absence. But my joy rests in knowing that God blessed me with my mom's presence for 13 years, and in that time frame, I learned tangible action items that allowed me to become a woman who is flourishing and growing. My mom taught me how to take care of myself, no matter the presence or absence of anyone else. She made sure that I knew how to cook, write checks, budget money, and advocate for myself in most situations. I didn't know that I would have to pull on those skills sooner than I would have liked, but I am happy that she gave me those lessons and that I listened.

My brother and I didn't expect on that Sunday morning in 2006 that we would lose our mom and face such an unspeakable difficulty at that point in our lives. Our mom had just attended a wedding the day before and spent time with extended family, so her death came as a shock, especially to those who had just danced with her not even a full 24 hours before. The surreal nature of her death felt like I was in a twilight zone. Having to bury her was even more difficult and exhaustive. We had two funeral services to accommodate family in Chicago and Atlanta. At the second service in Atlanta, I walked up to the casket with one of my favorite cousins holding my arm for support, and shortly after kissing my mom's cold forehead, my knees buckled, and I almost passed out. Luckily, my cousin's arm and the help of some man I can't remember became my saving grace from me hitting the ground. I now realize that I was burdened and overwhelmed with grief, sadness, and disbelief, so my body's way of handling all of that was to shut down.

Feeling sad and numb, my mother's death felt like it was the pinnacle of the amount of pain that I could ever handle. It was as if the worst thing in life had happened, and I felt lower than the ground I walked on. I wanted nothing more than to go to sleep just so I could wake up and realize that it was all a dream. However, sleeping was no help because I would always wake up knowing that it wasn't a dream. It's a reality that I have to endure forever; my mom was physically not coming back. The reality of it all caused a sadness that ran so deep that I often found myself sitting and crying silently. The sadness that overtook me during that time stressed me out and caused my hair to fall out a bit, which kicked my introversion into overdrive.

I never imagined that I would lose my mom in my teenage years when I would need my coach the most. Her death cut like a piercing knife, and to this day, the pain of her absence still lingers as I always feel as if I'm missing something. Just as smartphones have become a part of most people's daily lives that when we accidently leave it at home, we feel naked until we can get back home and interact with our phones again, not having my mom feels the same way but much worse. I can always go back home and feel refreshed once the forgotten phone is now in my hands, but that feeling of missing my mom is permanent; missing her and her physical presence in my life and heart can't be filled by something or someone else.

Some of the biggest and best athletes probably change coaches during the course of their careers, or even lose coaches to death. But missing your best coach doesn't mean that you completely throw away your interest in the sport or race that you've trained so hard for. Instead, you take the time off that you need to grieve and regroup. At some point, you will start training again, but this time with

multiple trainers who can come together in your time of loss to help you finish the race of life.

If life is a marathon, then the race of success is about figuring out your God-given gifts so that you can operate in your calling and make a tangible difference in the lives of others. Or if life is a boxing match, then overcoming life's most traumatic and difficult situations is not about just parading around the boxing ring in unhealthy pride. It's about showing the power of not quitting, televising your training sessions, being knocked down, taking breaks during training and then coming out victorious. Others from afar are able to celebrate with you because they've witnessed the process of your glow-up. The transparent, televised training sessions become evidence that this isn't an overnight success, and the marathon continues, even in the midst of adversity.

# Innerview Questions

Who are your coaches?

What are the biggest lessons that your coaches have taught you?

# The Marathon Continues

"If there's one thing that we can all count on, it's that tough times will find their way into our lives, but there's always a lesson within the tragedy, even if you have to search long and hard for that lesson."

My mom's death caused a shift in my life that forced me to mature quicker than others my age. Not only was my life changing, but my living arrangements were changing as well. My mom's death meant that I had to move out of the home that I shared with my family. It was a burden to deal with death on top of the immediate change of my environment. Immediately after my mom's funeral, I moved in with my grandmother and was enrolled into Percy L. Julian High School, which was different than the high school I was originally registered for. My mom died two weeks before I was supposed to start high school, so this meant that there was a last-minute scramble to find me a new school. I was supposed to go to Hillcrest High School with people who I had known since the fourth grade. Unfortunately, I had no choice but to swim instead of sinking when it came to blazing a new trail at a new school with new people.

My first day at Julian, I felt like a small fish in a big pond. I didn't know how I was going to make friends at a school where I didn't know anyone, so I put all my interest into my classwork as a way to take my focus off of losing my mom. But even in the new environment, the challenges of death were still present. During the middle of my freshman year at Julian, my math teacher was murdered by her boyfriend. That same school year, I was exposed to the impact of poverty and violence in the city in ways I hadn't really noticed before. There was a tragic shooting on the public transit bus route that many of the Julian students took to and from school. The bus was shot up, injuring multiple students and killing one. These were students who I didn't have personal relationships with but who I got used to seeing daily when passing in the hallway and from having friends who had classes with them.

This repetition of death shined a light on me appreciating my life and making the most of it, which meant thinking past my high school years toward my future. My sophomore year, my teacher Mrs. Gilbert-Mitchell took an interest in my potential and made it her business to ensure that I, too, saw that same potential within myself, and she became intentional about activating it and preparing me for college as my next step. Mrs. Gilbert-Mitchell coordinated and taught the AVID (Advancement Via Individual Determination) college preparatory program at my school. The program taught academic preparation, networking, and notetaking, exposed students to the college experience, provided scholarship resources, and taught other essential skills needed for success. From my sophomore year to senior year, AVID took us on college tours, to college fairs, and to meet with college

representatives. Mrs. Gilbert-Mitchell even had AVID alumni come back and speak to our AVID class to share their college experiences and any pitfalls to avoid.

At Julian, I was able to make friendships that I still have to this day. One of the most unlikely friendships I made was with my best male friend, Brian. He was a popular jock at Julian, and up until my junior year, I was the quiet geek. We met freshmen year because we had the same homeroom, and we realized that we lived just a few blocks from each other. By senior year, we were like brother and sister. Even in college, we held each other accountable even though we were hundreds of miles away. He went to an HBCU in Louisiana to play football, and I attended Central Michigan University (CMU). He's still one of my closest friends who has become ingrained in my family.

Brian wasn't the only friend I made in high school. My junior year, I watched myself blossom and make plenty of friends. By my senior year, I felt more comfortable at Julian, in the place where I had once felt out of place, and I had found my tribe and gained such a positive sense of community, which was exactly what I needed then and throughout my life. As fate would have it, a few of my friends from Julian actually went to college with me at CMU, and having a strong system in college away from home was excellent.

With the help of AVID and my high school tribe, I applied to just about every scholarship that I could get my hands on. Once I saw the price tag of college, I knew I couldn't dare put that financial burden on my grandmother. In my eyes, my grandmother had more than did her job with caring for me after my mom passed. So, scholarships became my solution for paying for my college education.

Based on my research at that time, I saw that there were more outside scholarships available for high school seniors compared to current college students, so I knew that I had to front load the work of applying for scholarships instead of waiting until I had already started college. I used to use my lunch breaks to go to our school's library, research scholarships, and start the application processes. I wrote the application essays from my heart and talked about how college was an avenue for me to further the lessons of education that my mom taught me before she passed. I highlighted how I excelled in high school despite losing my mom and how I intentionally learned from upperclassman from my high school that went off to college. I even mentioned how my education would allow me to impact my future college campus and my community back home. I sent out an unprecedented amount of college scholarship applications, and the secret sauce was having good relationships with my high school teachers who were eager to review my essays and write my letters of recommendations. It meant the world to have people help me by investing in my education and the growth that would come based on my college environment. And the icing on the cake was that I didn't have to recreate the wheel when applying to scholarships; I was able to re-frame many of my essays and use them for multiple scholarship applications, and it worked to get me all the scholarship money!

By the time high school was over, I ranked number three in my graduating high school class with above a 4.0 GPA, and my college tuition was completely paid for by scholarships. My grandmother knew that I was applying for some scholarships, but she didn't know the amount of applications I'd completed. It wasn't until my scholarship banquet that she realized that my college education

would be paid for. She was proud and overjoyed to see my dreams of going to college come true. She supported me every step of the way and trusted my judgement when I said that CMU was the college for me out of the other schools I was accepted to and received scholarship offers to attend.

I received outside scholarships from Lovie and MaryAnne Smith (former Chicago Bears coach and his wife), the Sam Walton Foundation of Walmart, National Hook-Up of Black Women, AT&T, AVID's Chicago Office, National African American Insurance Association, and Cosmo Beauty Supply Store. That's right; I even got a $1000 scholarship from the local Black beauty supply store near my house. I remember going there one day to get some supplies to get my hair braided when I saw a stack of papers near the register. I couldn't help but be nosey, and my eyes lit up when I saw that it was a scholarship application; I grabbed a few for my friends and myself.

In addition to my drive for academic success, I also began to look at life with a deeper understanding of the value of quality relationships and with an appreciation for life itself. I realized that life isn't necessarily short; it just isn't always promised. Most people say it'll get better by and by. Well, I needed evidence that "by and by" would soon find its way to me because I was struggling to cope. I was feeling like a zombie when even completing regular daily functions like going to the grocery store, getting up for school, or laughing at a funny joke. Eventually, I recognized that my mom had planted so many life lessons and words of wisdom in my life that in her absence, I was prepared to continue living a strong, faith-filled life. Strength can be found in the most difficult, heart-wrenching, and soul-crushing experiences that no amount of preparation can prepare you.

Of course, this revelation didn't come overnight. It took time and reflection, but nonetheless, I found my strength in that low place. I remember that low place purposely; I remember it so that I remain humble. I remember what it's like to feel that feeling that seems empty of joy, but it's full of so much grief that it turns into situational depression. However, I now know the feeling of triumph, pure joy, vulnerability, and healthy coping. Years later, I've learned to reflect on the conversations, funny moments, and the unforgettable life lessons. If there's one thing that we can all count on, it's that tough times will find their way into our lives, but there's always a lesson within the tragedy, even if you have to search long and hard for that lesson.

My mom's death provided me with two possible solutions: give up or get back in the fight of life and turn my trial into the ultimate triumph.

You may have a hint at which route I chose…

I got back in the fight.

# Innerview Questions

What relationships did you build during your most transitional and difficult situations?

What role did those relationships play in your ability to endure the difficult time?

# Not a Big Ten School, but We Make Big Ten Moves

"The positive relationships that students make in college are almost more important than the actual degrees that college graduates receive."

We don't have to wait until we climb to the highest height of success to become leaders. We can lead as authentic trailblazers right where we are. Leadership is like a road that's never been traveled; the road isn't paved until a trailblazer comes through and makes room for the actual path to be laid. That path sets a precedent for others to recall when they travel down that exact road. Leaders open the doors for others to follow who will then leave their own unique footprints in similar environments.

However, the path of a trailblazer is terrifying. Many don't get front row seats to the trailblazer's journey. They don't get to see how the leaders have to reaffirm themselves with positive affirmations to get rid of fear. Those who come behind won't be able to count how many times a leader stopped and questioned whether blazing a new path was even possible, important, or if it was their calling or responsibility at all. How many times did this leader question if it was even

worth the hassle of being the first, of making sacrifices, of having to personally evolve, or of having to become physically fit? Being a trailblazer involves the type of physical, mental, emotional, and spiritual fitness necessary to endure a journey that many would have quit during the first night of darkness or the first time it poured down raining. It's the motivation to show others what is not only possible, but also necessary to keep a trailblazer and a leader on their journey.

That journey sounds way too familiar for me because it represents my life in the same way that an authentic biopic relives the lives of our favorite entertainers and historical figures. When it was time to pick a college to attend for undergrad, I chose a school that I had never heard of prior to meeting their admission representative. Even my family looked at me crazy for not attending a big-name Ivy League school that would pique the interest of others. Central Michigan University (CMU) is a large, predominately white institution with about 20,000 students, but it sits in a small college town. CMU isn't a big ten school, but it's notorious for being the breeding ground for student leaders who activated their leadership skills through hands-on experience. That in itself is worth more than being advertised as part of the big ten athletic conference. Attending CMU showed me that it's not always about a college having a big name, but it's more so about doing the best with the opportunities presented to you.

As much as I wanted to explain to others why I chose CMU, it was almost too difficult to put it into words. Simply put, I felt an immediate connection, a God thing, when I stepped on the campus during my first visit, and I began to envision myself making that place my home for the next four years. I also got the strongest sense of peace when I meditated on my decision. When I had to make

the decision of where I would spend the best four years of my life, I simply chose the place that would provide me with the resources to grow as a leader and graduate with the least amount of college debt. When adding up my financial aid, CMU scholarships, and outside scholarships, my total four years at CMU were completely free, leaving me with zero student loan debt when I walked across the graduation stage. CMU also showed me that leadership is a transformative tool for personal growth, especially when learning to pursue a thing and obtain it. In this case, the thing was my bachelor's degree. It was the first step of my journey in being the first in my immediate maternal household to graduate with a degree, the first within generations of my maternal side of the family to even get a master's degree, and the first to pursue a PhD.

College was more than just classes; it was an experience that afforded me the growth that I don't think I would have been able to get anywhere else. College provided me the experience of moving away from the familiar, and it allowed me to operate in maturity so that I could understand the consequences of my decisions and the journey ahead of me. There was no way possible that I could return home to the South Side of Chicago without my bachelor's degree. Not finishing my degree would have made me feel like a failure. However, looking back on it, it wasn't the degree that made me successful; it was my ability to persevere, go through bad times, and still stand tall as a whole person, not shattered in pieces. Much to my surprise, I found people in college with the exact same mindset as me and who also refused to return to their hometowns without their degrees. This alliance brought me a community of accountability throughout my years in college.

It was something special and different about the people at CMU that came in with me during my first semester of college. It seemed like many of them were all equally focused and determined, and being surrounded by like-minded people made the college journey that much easier. The students who were from Chicago, Detroit, Saginaw, and Flint just connected automatically. We could easily relate to each other since many of our cities and neighborhoods were similar. During our first two years of college, most of us lived in the same dorms, played pranks on each other, and celebrated when we got internships and good grades. We unintentionally formed an alliance, and eventually, many of us became members of our respective historically Black fraternities and sororities around the same time. It became a sense of familial unity with us across campus that still rings true until this day. Currently, I talk to people I went to college with at least three to four times a week. Whether that's a conversation with my line sisters from my sorority, college roommate, or regular college friends, my college relationships are still intact.

Call me dramatic, but I will go as far as saying that the positive relationships that students make in college are almost more important than the actual degrees that college graduates receive. As an atmosphere for gaining those positive relationships, college offers the ability to learn from other students that may have more experience from their time on campus. It's more than just making friends who are on the same academic and professional level as you; it's also about finding those who are more experienced and accomplished and watching how they successfully navigate the college experience.

I think back to my freshman year, and I am amazed that I had the wisdom to look for upperclassmen of color who were doing positive things on campus and were leaders in every sense of the word. I knew that I had to learn the method to succeeding and conquering a new place, so I was intentional about seeking out positive relationships. My freshman year, I attended a residence life event on sexual assault awareness and campus safety. The event featured current CMU students who were part of SAPA (Sexual Assault Peer Advocates), and they put on a performance where they acted out scenes and provided students with knowledge on how to not be bystanders of violence and sexual assault. There was only one student of color that I saw in the cast, Al Jones, and he had on Greek letters displaying his membership in a historically Black fraternity on campus.

Al was a junior at CMU, and I remember seeing him in so many various campus leadership roles to the point that I was convinced he either had a twin or a clone. If that wasn't enough, he always made himself known to underclassmen by checking in on their campus experience and providing great advice on how to navigate the campus as Black student leaders. On campus, he was looked at as royalty to the point that some of the other student leaders referred to him as Thee Al Jones. Although it was used in a joking manner behind his back, it was also a serious way to applaud his sacrificial leadership, which paved the way for other student leaders to activate their own growth and take over the campus. It was this cyclical leadership that showed me the blueprint to college success, campus leadership, and even professional development. Knowing that I wasn't on the journey by myself gave me the confidence I needed to get excited about conquering a new scene.

I was especially empowered to make a difference on campus after seeing Al make CMU history by becoming one of a few Black men to win CMU homecoming court. I not only witnessed Al's leadership, but more importantly, I saw how he intentionally went out of his way to mentor other students, share his own experiences, and direct students to accomplish more than what Al himself did on campus. More than seven years after his graduation, Al is still that same living legend on CMU's campus. This lit a fire of determination within me to continue servant leadership in my own life. It's one thing to recognize authentic and game-changing leadership, but it is another to say thank you.

About five years after my college graduation, I contacted Al because I was scheduled to be in the same city where he and his family reside. We made plans to grab dinner, and I was excited to share with him my thanks and appreciation for the direct and indirect mentorship that he provided during my time at CMU. During dinner, I got to meet his wife and hear about their collective professional journey. Mostly importantly, I got to express my gratitude and provide some concrete examples of how Al's past campus leadership and current student affairs career has been monumental in my own professional, academic, and personal growth. He was appreciative and almost in disbelief that his own journey had that much of an impact on my life. I confessed about his nickname of "Thee Al Jones" that his college mentees had given him, and he laughed as if he thought I was joking until I told him that the nickname was legit.

During that dinner with Al and his wife, I realized that it can be common for people to be genuinely amazing and transformational leaders but become so accustomed to their greatness and impact that it becomes normalized. When we lead, we literally can't visually see ourselves leading; it sometimes takes outsiders to mention the progress and impact of our leadership for us to take those accolades into serious consideration. Bishop T.D. Jakes once compared the inability to see ourselves as leaders to the biblical text when Jesus asked, "Who do men say I am?" We can do great works, but the feedback from those outside of ourselves can provide assurance as to the impact of our work.

# Innerview Questions

What big decisions have you made that you are proud of, even when others didn't initially understand the reason behind your decision?

What have been some of your biggest hurdles?

# Perspective Makes the Difference

"Living by myself in another country was once an area of wilderness that I thought would break my spirit; instead, living abroad became a highlight and testimony of my ability to maintain faith, make new friends, find the silver lining, and learn my own strength."

There's freedom in learning that you are built to succeed, no matter the circumstances or the environment. It's sometimes the hardest lesson to grasp because it is taught in the most difficult situations where winning is the only option. Learning great lessons is like competing in a boxing match, and the trophy we get at completion is like winning the heavyweight championship belt. Little do people know, winning that championship belt took years of trusting the process; it took physical strength, mental toughness, conditioning, and training. My winning mentality was put into overdrive the first semester of my senior year of undergrad when I decided to study abroad.

During my junior year of college, I randomly decided to get a graduation audit done. I wanted to be sure that I had taken all the classes I needed thus far and had a list of classes I needed to take in the future to graduate. I only knew

what a graduation audit was because I had overheard a friend talking about it, and it sounded interesting. I was staying at CMU that summer, so I made my appointment to see what the graduation audit hype was all about. I knew that the waiting list would be shorter than usual since most students weren't on campus during the summer. The day of my appointment, I walked over to the Warriner Hall where many of the administrative offices were. The advisor calculated my class hours and then did a recalculation, which made me a bit uneasy. To my surprise, he mentioned that because I had taken summer classes two summers in a row, I was able to graduate a semester early if I had wanted to.

Graduating in three and half years would have been a great accomplishment, and I'm sure that it would've looked great on paper. However, I knew in my heart that getting my degree ahead of time wasn't for me. The biggest part of self-awareness is paying attention to that still small voice or that tugging that helps us take the right course of action. In college, I took advantage of just about every single opportunity that I could get my hands on. Many of those opportunities I learned of just by watching others around me take advantage of those resources first. However, I knew that I didn't want to graduate early just to go around bragging about the accomplishment. I had a decision to make. I knew that there was one piece missing to my undergraduate career, and that was studying abroad.

I'd set up an appointment with a study abroad advisor to learn more about the process and to hear stories about past trips of CMU students. Staying at CMU for the summer made getting an appointment a true breeze. Luckily, I was paired with a study abroad advisor who loved her job and was so welcoming to all of my

questions. During our first appointment, we reviewed my location options and the price tags. We considered about two to three different places with Singapore and South Korea being viable options. After multiple meetings, it wasn't long before we realized that Singapore was the perfect location for me, and everything worked out perfectly with me picking the classes I needed, applying to scholarships, and even purchasing my plane ticket. The ease of the location selection was an early indication that I was on the right path with preparing to execute this decision. Just like with picking CMU, I paid close attention to the peace that was present when I spent time thinking about the study abroad program and researching the Singaporean institution.

My study abroad advisor was such a huge help. She recommended me for a $2500 study abroad scholarship from her office, and I was chosen as the recipient. Funny enough, the Department of Journalism offered a $600 scholarship for students from my major studying at the exact same university in Singapore, Nanyang Technological University (NTU), which was one of the top 100 universities in the world. I won that scholarship as well, and it was clear that this trip was meant to be.

One thing I found out during my research was that only a small percentage of CMU students actually go abroad every year, and an even smaller number of Black students study abroad each year. That meant that there were plenty of scholarship programs looking for more underrepresented students to apply. For instance, I applied to the Benjamin Gilman scholarship from the U.S. Department of State, which was directed toward those same underrepresented groups. I applied and received $1000, which helped me pay for my $1700 round trip plane ticket.

The Study Abroad program scheduled a pre-orientation for all study abroad CMU students who would be studying together in the same location. I was unable to attend the pre-orientation because I had a meeting that same day and time. I asked my study abroad advisor to just pass my contact information along to the other CMU students who would be going to Singapore. My advisor emailed me back with the daunting news that I was the only CMU student who would be studying in Singapore that semester. I definitely rethought my trip when I heard that. I was prepared to travel more than 9,000 miles away from home, missing my last undergrad homecoming, but preparing for a four-and-a-half-month long solo trip wasn't a part of my plan. I had a lot to think about, but I knew what the decision would be. This was a trip of a lifetime that was completely paid for, and I got peace whenever I thought and prayed about it. My family was nervous because many of us couldn't even point to Singapore on a blank map before learning of my trip. I had the responsibility of assuring my family I would be safe and sound as well as the benefits of me going abroad.

When the day came, I headed to the O'Hare International Airport to begin my journey to Singapore. My grandmother took me to the airport, and it was an emotional moment for us since we both knew that I would be thousands of miles away from her. My flight was about 24 hours, including a four-hour layover in Hong Kong, China.

Initially, it was a huge shock to be immersed in such a different culture, but it was such a privilege to learn about people who didn't look like me and to understand their way of life. As great as the trip was, I became uncontrollably homesick. The first month was crucial, and I honestly cried every day in my

morning shower. I remember waking up feeling so sad that I was pretty much sulking around, but something eventually clicked during that first month. I was having the opportunity of a lifetime, and what I was facing wasn't impossible to overcome. I prayed more, read my bible more, and journaled down every thought, emotion, and goal. I even reached out to my inner circle and talked about my emotional state, and in all transparency, I told them that I really needed their encouragement even if that encouragement came from an email, a phone call, or a text message. This was one of those times when I had to rely on my support system while I found my own strength.

During my period of homesickness, I also reached out to my study abroad advisor and made it clear that I was strongly considering leaving Singapore and going back home. She assured me that my feelings were normal and that making it through the first month would set the tone for the remainder of my trip. I promised to push through the first month and reassess things from there. She also put me in contact with a CMU student who studied in Singapore the semester before I did. That student then put me in contact with her Singaporean friends who I declare were angels from God. Her one friend in particular, Filzah, took me around to many cultural areas. We traveled to the Singapore Botanical Garden, Orchard Road (filled with all of the most expensive name brand stores), movie theaters, and authentic Singaporean restaurants. I stayed in the dorms, so my next-door neighbor even chipped in and showed me around. She took me to Simply Pancakes, which served American-style breakfast. As a person who can eat breakfast at any time of day, this piece of home warmed my heart, and soon, my homesickness started to vanish.

Once I changed my perspective, the entire trip turned around and became such a great highlight of my life. Living by myself in another country was once an area of wilderness that I thought would break my spirit; instead, living abroad became a highlight and testimony of my ability to maintain faith, make new friends, find the silver lining, and learn my own strength. Studying in Singapore was monumental and essential to my future. It provided me with clarity on my next steps in preparation to graduate in five months after my return to the United States. The feeling of knowing that I can thrive in any environment added to my confidence and prepared me for whatever life would throw at me. It also provided me with the flexibility necessary to know how to lead on new levels in new places.

To start leadership in new places, I learned that all I initially needed was the right perspective. A positive and faith-filled perspective changed the entire direction of my trip in Singapore. I went from being extremely sad about being away from friends and family to being grateful for my experience. I went from being overwhelmed with the level of rigor in the work to learning new study habits for success. I went from feeling like a small fish in a big pond to learning my way around Singapore and being able to take public transportation by myself without getting lost. My change in perspective made all the difference, and those lessons and life experiences lasted years beyond my time in Singapore. I now know that I can thrive anywhere anytime.

# Innerview Questions

What were some of your areas of wilderness that turned out to be a place of growth?

What shaped your perspective during that time of wilderness?

# Prepare, Perform, Repeat

---

"My dad's opinion is always present when I need advice,
and it helps me watch my blind spots when I need to fully
think out a decision or unpack an idea."

M any of my greatest accomplishments started with a far-fetched idea I
shared with my dad. He is like the Charlamagne (the radio host) of my life.
My dad is honest and straightforward without any fear of speaking his mind. His
military background provided him with his extra no nonsense personality that
grows like a fire in a summer grill fueled by lighter fluid. Not only have I inherited
his personality to the point of having to unlearn some of those traits, but his
personality and ability to provide criticism has also been monumental for me. His
opinion is always present when I need advice, and it helps me watch my blind spots
when I need to fully think out a decision or unpack an idea.

One of my far-fetched ideas was something that even I believed was out
of my reach initially, but my safe place to discuss these ideas was always in my
dad's house. Many of those ideas were vocalized with a bit of trepidation while
sitting in my dad's living room. During many of my visits to his house, I would
randomly declare, "You know, I think I want to XYZ." Whether the XYZ was

starting a speaking business, applying to a PhD Program, leaving my corporate job, or even starting counseling, it was as if my dad instinctively knew that those XYZ's were meant for me. He was my sounding board that gave me logical advice, not just confirming what I wanted to hear. He always replied, "Well baby, you know you're going to do it or accomplish it just because you've said it. And when you say what you want, you always get up to go get it."

And you know what, my dad was right. Whenever I made a proclamation, the mere fact that the thoughts left my brain and were expressed aloud was all the reason that I had to transform that dream into reality. But it was about more than just me sharing my wildest dreams and goals with my dad; it was the fact that he believed in me. I didn't always talk about my goals with all the confidence in the world. Too often, the what if's multiplied in my mind quicker than I should have ever allowed. My dad could see both my passion and the room for more confidence. He did what most fathers would do in that moment, and he told me that I could do it. My eyes would always light up because my dad is the realest realist. He holds no words when he speaks, and if something isn't in order or doesn't make sense, he's the first to offer up that truth. We all need a cheerleader in our corner who refuses to be our "yes man." We need someone who will cheer us on as we continue fighting in our boxing match and who also isn't afraid to be our motivator when life knocks us down in the ring or when we begin to lose a bit of hope and faith.

Once I gained the motivation and confidence I needed from expressing my ideas, the next step was to harness the focus necessary to plot and plan every step as if failure wasn't even a plausible option. I admit that when I'm focused on

a goal, I zoom all the way in with laser focus. It's kind of like the police surveillance cameras that can be 50 miles away, but with the press of a button, the cameras can zoom in and analyze something as if they are right next door. I always pair my focus with a level of planning that's airtight. Murphy's Law says that everything that can go wrong will go wrong, but my airtight planning leaves no room for the slightest bit of Murphy's Law to possibly happen. My level of planning includes dates, times, details of business conversations, excel spreadsheets, and alternate routes to get to the desired destination. It's not to say that I never get distracted during goal planning and execution, but my level of planning enables me to quickly recognize something as a distraction and then attempt to rid myself of it.

It's almost like planning for a bank robbery, non-violent of course. Once the decision is made to rob a bank, you start acquiring team members, and you ensure that those team members have the strengths team needs in every key area. The best driver will be the one to drive the get away car. The person that's best with observing their surroundings is the one to be on lookout. The person with the best ability to stay calm is probably the leader that will walk into the bank and get the job done. Sometimes, the best plotting happens when the right team members are all in place and ready to assist as need be. So, we have to make sure that we've plotted and planned thoroughly, including a few escape routes, so that our goals and ideas that have the greatest potential turn into reality.

# Innerview Questions

What is your safe place to ramble off your goals and dreams?

How do you prefer people to communicate constructive criticism?

# It's Not for You, It's for Me— Forgiveness

"My dad wasn't always a part of my life. Believe it or not, growing up I only knew what he looked like by rambling through old pictures, not from seeing him face-to-face."

The infamous phrase, "It's not you; it's me," still makes me laugh until this day. Probably because it's famous for being the line used in breakups and a way to deflect the denial that comes with them. Similarly, the idea of forgiveness fits this statement perfectly. Forgiveness isn't for or about the other person, it's about us lifting the burden off of our own backs.

I mentioned earlier how appreciative I've grown for my dad's wisdom and concern with motivating me during times of uncertainty and progression. That in itself is pretty ironic because my dad wasn't always a part of my life. Believe it or not, growing up I only knew what he looked like by rambling through old pictures, not from seeing him face-to-face. For the life of me, I couldn't understand why or how he wasn't a part of my life. My mom tried to explain it the best way that she

could; her explanation was that my dad was going through his own phase of "stupidity," and that as my mom, she loved me no matter my dad's choices.

Years later when I was in the sixth grade, he came around and wanted a relationship with me. He'd had a stroke during that time, and the man who traveled the country for two to three weeks a month for work was now not allowed to drive per the doctor's order; he then had some time to think about his decisions and relationships. I suppose that break from work was the solution to the drawn-out "stupidity" that my mom described.

My father came over to my grandmother's house one day and sat on the couch with my mom and me. All I could do was look at him with the meanest look that I could create. Here was the man who wasn't an active father for years besides consistent child support. How was I supposed to feel? I was disappointed in the man that sat across from me. I had so many questions that his answers would have never sufficed. He wanted to talk, but I didn't. There wasn't much I wanted to hear that would change the facts of the case. To make it even worse, I thought back to one encounter with him that happened when I was probably no more than seven years old and my brother was seventeen years old. Seeing him felt as if alcohol was being poured on an open wound.

When I was seven, my mom, my brother, and I had moved to a new house. One day my brother and I were sitting on the porch when my brother screamed with excitement and pointed directly across the street yelling, "There goes Nate!" I knew that was my dad's name, but it didn't make sense that my dad would be anywhere near our home. As it turned out, one of my dad's close friends lived across the street from us, and that day I got a chance to see the man who I had

only seen through pictures. He was caught off guard by seeing us and didn't know how to process the encounter, let alone what to say. At that moment, he had to either face his failures as a man and a father or turn and continue to ignore us. He wasn't the failure, but his actions were a failure. His decision to not have a physical presence in my childhood was his burden to bear, and in that very moment, he couldn't run. He had no choice but to be physically present and process our face-to-face encounter. However, he wasn't ready to face his own mistakes then. About three years after seeing him across from the new house, he gathered the strength and wisdom to right his wrongs and create a father-daughter bond that would be more valuable than he and I could have imagined; neither of us knew that in less than three years, he would be my only parent.

Him attempting to right his wrongs was a process that took work. The start of that hard process was evident when he visited me at my grandmother's home. I guess my mean look and silent treatment was something that he wasn't ready for. He and my mom stepped into the room near the living room and had a private conversation because he was unsure of how to handle the attitude I gave him in that moment. I use the term "private conversation" loosely because I could clearly hear every word from where I sat. He told my mom that he was hurt that I didn't want to talk to him, but my mom assured him that I would come around; he just had to keep trying. Well, my mom was right because I eventually came around. I went from not wanting to hear a word from him to him being my biggest cheerleader, to us having a relationship that I cherish, and to me laughing hysterically at his jokes.

My dad won my heart by taking me out for food and using that time to have conversations. He apologized for his absence in my life and promised to never leave my side. He also asked for my forgiveness, and that broke the dam of tears. The unforgiveness in me was nothing more than me not understanding his absence; it was me growing up as a young girl who blamed myself for my dad's inactivity as a parent and me wanting nothing more than to have a strong bond with my dad. I masked all of those feelings when I showcased my discontent in the past. I had to forgive him for myself. I had to find the strength to rid myself of that weight of unforgiveness, and I did. Here I was barely a teenager, but I had enough wisdom to know that I had to release the pain he caused me.

Had I not forgiven my dad and allowed him back into my life, I would have been parentless. None of us that day knew that my mom would die less than three years after my dad and I reconnected. Her death was the passing of the baton to my dad for him to cultivate our relationship even more. Had I been stubborn and not allowed my dad back into my life, I would have been doing myself a disservice. I would have hurt my own life and future legacy work while thinking that my actions were inflicting pain upon him.

I'm sure we've all had people in our lives who have wronged us, and we all have the right to be upset or to choose to remain estranged. There's validity in being hurt because someone has hurt or wronged us, but leadership isn't just about leading and enjoying the highlight reel that others see. Leadership is about renovating those internal spots that harbor unforgiveness, sadness, hate, and denial. It's about growing through what we've gone through because life happens

to us all. And as my dad so eloquently phrases it, "And if life hasn't happened to you yet, then just keep on living, and it will."

# Innerview Questions

Who has caused some of your biggest hurts thus far in life?

How would you describe your ability/inability to forgive?

# Behind the Stage Sets the Scene

---

"Public speaking meant so much to me, and I was careful
not to expose that part of my life in a toxic work
environment in fear of those who would attempt to ruin my
exit plan."

---

D o you remember when MTV had a show called *MTV Diaries*? It would show the day-to-day life of our favorite pop culture celebrities, and the tagline for the show was, "You think you know, but you have no idea." Years later, that quote still resonates with me because just like the behind the scenes of a celebrity's life, many of us don't know the process that people use in order to make goals and dream a reality. Our favorite foods have a cooking process, many of our most meaningful relationships involved a dating process, and despite the portrayal from social media, success doesn't happen overnight. It's all a step-by-step orchestration of greatness.

After I sat on my father's couch and talked about my future speaking career, I started the long process, though it was quicker than most, toward building a speaking career that I deemed to be a success. Yet, there were tons of people who would say, "I see you're speaking; your career has taken off almost overnight."

Not only would I cringe every time I heard that comment, but I also wanted to run down the list of steps and sacrifices that got me to their ideal point of success. From the outside looking in, the audience may believe that success is easy. It's actually the farthest thing away from easy. What success lacks in ease, it makes up in worth. Some of the greatest difficulties in success include sacrifice and hard work, but the reward makes it all worth it.

At one point, my journey included working a full-time corporate job, teaching an evening college class, and traveling almost every weekend to speak. I was working a corporate job in the financial services industry that afforded me a financial lifestyle to take care of myself, have disposable income, pay tithes, and put money into a savings account on a monthly basis. At 23 years old, I was making a bit more money than I could even spend, but that didn't matter because I wasn't happy. I wasn't happy with the job because the work environment wasn't conducive to my passion for true diversity, inclusion, and equity in the workplace. Although I created and cultivated meaningful relationships across the enterprise, my immediate team didn't feel like much of a team to me. I wasn't always unhappy with the job.

When I first started working at that company, it was part-time since I was working on my master's full-time. My first position was in the human resources department, and I loved it. I had gained a work family there and the team was supportive and provided me with the chance to learn the ins and outs of how their department functioned. With my part-time position, I was able to lead the company's program that provided summer internships to high potential high school students, with many of the students being students of color. It was almost

blissful. Once I graduated with my master's, I was offered a full-time position in the IT department and it seemed like a great opportunity to learn a new skillset in another part of the company, even though it meant that I would now be working with a team that I was totally unfamiliar with.

It didn't take me long to realize that my unhappiness stemmed from me realizing that my position as an IT business analyst wasn't remotely my passion. Sadly, I didn't make that realization until I was already months into the IT role and someone else had moved into my old role in the HR department. Nonetheless, I knew that a shift would arrive soon and allow me to leave my full-time job, and it was on me to prepare for it. I wasn't quite sure if the shift would be leaving my full-time job to go back to school or if I would go into speaking full-time, but what good would the shift have been if I wasn't ready for it when it arrived? At that point, if my life was a stage play, then I needed to prepare behind the stage in order to set the scene of flourishing beyond this job.

Preparation and setting the scene meant showing up to my corporate job daily, not just physically but mentally too, while executing my strategic exit plan. Good ol' exit plans are necessary when trying to reach your desired destination. I've always been uncomfortable around large crowds, like those in stadium-sized concerts for example. To ease my nerves, I immediately look for multiple exit signs. My theory is that even if one exit is closed or crowded, there's always another route. Now I look for exit signs in just about every establishment. While the exit plan theory is true for music arenas, it's also true in preparation of a shift, exiting one level of our journey and leveling up to go even higher.

In the meantime, my corporate job got so stressful that a medical appointment for purchasing life insurance showed that my blood pressure was abnormally high one day, which was also the morning of a scheduled meeting with my boss. My boss and I just weren't for each other, and I wasn't a fan of her communication style, which often felt condescending and insulting. It got to the point where walking into work became a literal task for me. There were times when I had to talk myself into getting out of the car and going into work in the morning. The unfulfillment stemmed from me knowing that I wasn't doing anything close to the things that made my heart smile, like speaking and teaching. Luckily, I was still teaching a college class in the evening after work, so I was still working my passion in the midst of my full-time IT position. I constantly reminded myself that my unhappy circumstances weren't permanent, and I just had to be a good financial steward in the meantime so that I could leave my job and still maintain my financial security.

Although I didn't enjoy going to work each day, I admit that the job provided me with a greater sense of self. It taught me to trust myself and my faith. There were even times when I relished in the financial benefits of the job, but I had to often remind myself that "this isn't a court case, so settling isn't even the slightest option." I continued to have this feeling and sense of knowing that it was time for me to prepare my departure. Eventually, it went from just a feeling to a knowing that repeated itself so much, there was no denying the steps that I knew were coming next. My personal assurance became so strong that months in advance, I started to clear my desk because I even knew what my next step would be.

I knew that my time there was temporary. I had to stay encouraged, which meant doing whatever it took to lift my spirits daily. One thing that helped me stay calm during the week was my additional position as an adjunct instructor at the nearby university where I taught an introductory public speaking class. I would drag myself to work corporate during the day, and I would get a second wind when it was time to drive 10 minutes to my campus office and prepare to lecture that evening. I loved engaging with my students, and it was clear to me that teaching was part of my purpose. Speaking was picking up quite well simultaneously. So, when I wasn't working corporate or teaching, I was traveling just about every weekend to speak at conferences and colleges/universities.

I was getting so anxious to leave the company that when I traveled for speaking, I was actually excited for the two-hour drive to the Chicago O'Hare International Airport or the Midway Airport, which were the closest major airports to Bloomington, IL. When flying back to Chicago after speaking, I would always get the earliest return flight so that I could attend church in Chicago. Church was always amazing and uplifting, but a heavy feeling of sadness would always come over me whenever church service was nearing the end because it meant that I would have to drive back to Bloomington and get ready for work the next day. I would cringe at the thought of walking into work.

As tiring as the constant traveling became, I gained a renewed sense of strength doing what I loved on a constant basis. I would travel out of state and speak in front of hundreds of people and then turn around and return to the corporate life as if I hadn't just preached the paint off the walls at my last speaking event. Eventually, it became awkward for me, and I started to feel like I was living

a double life. It got to the point where I felt as if I was Clark Kent and Superman. Very few people at my corporate job knew that I was also a public speaker. I wasn't sure if my work team in the IT department would be supportive of my speaking career or if they would be tempted to mention how I chose to use my paid time off to my boss. Public speaking meant so much to me, and I was careful not to expose that part of my life in a toxic work environment in fear of those who would attempt to ruin my exit plan.

One part of the exit plan was to save up as much as I could from my salary and from teaching and speaking. I gave myself this far-fetched goal of saving $15,000 prior to leaving my job. That entire year was full of budgeting and discipline. It got to the point that my cost of living in Bloomington, IL was so low that I didn't even need to spend my money from speaking and teaching. My corporate job took care of my bills and still provided me with leftover money, so maybe my savings goal wasn't so far-fetched.

In addition to reaching my savings goal, I also used my corporate salary to invest in the beginning of my speaking career. This is one reason why I don't believe in the hype of people feeling as if they can't work a typical 9 to 5 and still be an entrepreneur. I'll be honest and say that my corporate job was a huge investor in my speaking business whether they knew it or not. I allowed my job to fuel my business until I was able to smoothly transition out of the job. No matter how much I started to dislike my corporate job, that position was a blessing because it taught me how businesses are ran and how high-level decisions are made and then spread across an enterprise.

Like anyone interested in starting a business, I researched the industry and other speakers who were performing in a similar fashion. I looked at websites, social media profiles, and past speaking events, paying close attention to the keynote speakers. I searched the websites of a variety of speakers to see what professional speakers needed to have as promotional tools, and I looked through online conference booklets to see which speakers were being brought into universities to engage with students. I especially did research on those who would soon become my competitors in the field.

The best part of leadership is that we don't have to always re-create the wheel when embarking on a dimension of leadership. There are people who have executed the steps before us, and the beauty remains in being able to follow and modify their steps and blueprint for our needs. Thanks to the internet, we can use social media to learn about the process of elevation and leadership from people we have close bonds with and from people who we have never physically met.

Later that year at the National Conference on Student Leadership, the largest student leadership conference in the nation, I actually got to meet many of those speakers I learned about from my research. What are the odds? I let each of them know that I respected their craft and how much they inspired me to excel in my own speaking career. While I was preparing for my shift, the things that I studied and fixated on began to manifest in my life quicker than I could've imagined. My prayers were being answered, though not on my expected timeline, but the timing was perfect nonetheless, and I was ready to leave the corporate life and work in my purpose. By the end of that year, I had reached my savings goals

of $15,000 even, so I knew that my shift out of the corporate job would come soon.

## Shifting Gears and Moving Forward

The shift I had been waiting months for finally came. I remember that day perfectly! It was the first week of March, and I was leaving my work building to drive to another work building for a meeting. My spirit was getting weary because I was anxiously ready to leave my full-time job. While I was thankful and blessed to have had that job, I knew that there was more for me on the other side. My lifeline that would allow me to operate within my gifts and passion had finally arrived, and it was the perfect exit strategy that connected with my passion for learning and higher education.

Unbeknownst to me, my shift and lifeline would include pursuing a PhD at University of Missouri (Mizzou)-Columbia coupled with advancing my speaking career. Before applying to the doctoral program at Mizzou, I found out that admission required that I take the GRE, which is a four-hour exam that costs about $250 each time. Since I had discovered the PhD program four months before the application deadline, I had a short timeline to take the GRE. Immediately, I went online to search for and purchase some study materials on Amazon. I studied for the GRE during one of my busiest speaking seasons, and I found myself studying in hotels and on airplanes. I essentially had to relearn math that I had learned in high school to be ready for the math portion of the exam.

Within the four-month timeframe, I had taken the exam twice. The first time was to get my baseline score and find the areas where I needed to focus more

on during my study time for the exam retake. I knew that studying for the GRE and preparing my application materials would require laser focus, so I didn't tell too many people that I was applying. The ones I did tell were trusted friends and family members who I knew would hold me accountable and see to it that I actually applied. Not only did I take the exam twice, I actually improved my score overall by a total of eight points, which is unheard of. The average person typically improves their overall GRE score by about four points when they retake the exam. I'll be honest and say that when I saw how much I improved the score, I thought it may have been a computer glitch or mistake. I was expecting the testing companying to try and investigate me for suspected cheating. But I didn't cheat, and it's nearly impossible to cheat on the exam since the proctors essentially ban cell phones and all other personal items in the exam room. It wasn't a glitch or mistake; it was the manifestation of God's promise to always be with me and a reward to my faithfulness of studying for the exam.

But back to the shift. One day when I was pulling out of the parking lot of work, I received a call from an unfamiliar number. I answered the phone and realized that it was the director of graduate studies from the Department of Communication at Mizzou. My heart sank to my stomach because I immediately started praying that the call wasn't to inform me of my denial into the program. Instead, it was a call to present me with acceptance into the doctoral program for Communication: Identity and Diversity and with an offer to join the department as a graduate assistant, which would allow me to teach two public speaking courses and included free tuition and a monthly stipend. I was then only responsible for my living expenses and student fees each semester. That was it! That was the shift

that I was waiting for. It was the shift that I had cried and prayed for. I had to mute the phone as the director began to run down a list of formalities with my offer. I was balling with tears of joy in my car at that moment. My shift arrived in a sleek package wrapped in a perfect red bow. I don't know if I've ever been happier to get an acceptance letter.

It was then time to put everything in motion, and I was more than ready.

By the end of that day, I pulled out a calendar and calculated how much money I would need for living expenses if I left my corporate job four to five months in advance of me moving to Missouri for school. The lease to my apartment was month to month at that point, so all I needed was to provide the leasing office with a 30-day notice of my plans to move. My bank robbery-like planning skills went into overdrive, and within about 48 hours, I was ready to activate my plan. Of course, I sought wise counsel and shared my plan with trusted members of my tribe first. Many of them laughed when they realized that I had been planning for my escape for a little less than two years, but they still gave me their advice and support. It was clear that I had thought this through thoroughly. So, my approaching them was to inquire of any alternative options or blind spots in my plan that I hadn't thought of. Some mentors provided me with advice on making sure that my exit from the company was graceful, despite my unhappiness with the work environment.

Finally, the day came for me to announce my resignation and submit my formal letter. My brain was going into overdrive that entire day, and my nerves were getting the best of me. I had butterflies in my stomach, and I kept asking myself the same question every 5 seconds: "Am I really making the right decision?"

It got so bad that I started asking myself aloud, "Nat, are you sure this is the next step you're ready to take?" In all seriousness, it was the moment I had been praying for, and here I was second-guessing everything. The letter of resignation was typed and signed, but I held it tighter than a million-dollar winning lottery ticket. In a sense, it was my winning lottery ticket worth more than gold and money. This letter represented my sanity, my happiness, and my peace of mind. It was go time. I knew and could feel it, but there was just one more confirmation from God that I needed. I had prayed to God and asked him to give me one clear, outlandish, outrageous, blatant move of God to show me that it was in fact time for me to announce my departure from this job.

Right on time as always, God swooped in and answered my prayers about two hours before my meeting with my boss to announce my resignation. Another manager from our out-of-state office sent me a random meeting request; she happened to be in our Illinois office and was present in a meeting that I led and where I delivered a presentation. Now, I didn't formally know this manager, but I accepted her last-minute meeting request and went to the meeting. I had no real idea of what to expect since I only knew her name, title, and location. I walked into the meeting room and settled into a seat while I waited for her to walk in. Much to my surprise, in walked a Black woman. You could have knocked me over with a feather. The company I worked for was notorious for having an immensely small number of Black employees; I could literally count out the amount of Black people that worked for the company. Even after seeing that she was a Black woman, I didn't put the pieces together as to where she came from or why she wanted to meet me of all people.

She walked into the room and let out a bit of a laugh because of my facial expression. "So, you're clearly wondering who is this Black woman that wants to meet with you?" I had no choice but to laugh too because she was clearly blessed with the gift of mind reading. I sat there listening intently because I knew there was some reason behind our gathering. As the conversation continued, she asked me about my hometown, educational background, and professional goals. I answered all of her questions, and I even mentioned my speaking career and teaching background. The next words out of her mouth rang loud like a bell and stuck with me: "Natilie, I need you to hear me loud and clear. You won't be here with the company long; I can see your passion for speaking and teaching. Be confident when you speak because that gift will take you far. Don't second-guess your decision to pursue your passion."

When I tell you that I had to stop myself from having a pure praise break in that meeting. This was the exact answer to my prayers. This woman didn't know me from a can of paint, but her words were the exact manifestation of what I knew God was making clear as day; I had just received a stamp of approval to leave the company. All I could do was tell her thank you and that I appreciated her sharing what God had put on her heart. I then pulled out my letter of resignation and showed her that her words were in perfect timing. I revealed that my upcoming meeting with my boss was to pursue that exact purpose. Again, she laughed and told me that if I needed any indication that I was making the right choice, God had just provided it to me; all I had to do was walk into what I could see was clearly laid out for me. So, I gladly put in my two weeks notice on that day.

After resigning from my corporate job, I decided to move back home to Chicago for about four and a half months. I gladly rented a U-Haul to move my stuff and loaded up my car. I decided to take a little extra time to move home because I knew that I would be moving away from Chicago soon to start my PhD program and that meant I wouldn't be returning to live in Chicago for some time. I also knew that I would need to recharge by being around my friends and family before I took that leap of faith and conquered a new arena. But pursuing my PhD wasn't where my shift ended. More shifts started to appear, and I was unsure if I could even handle it all. Change was on the horizon, and as scared as I was, I walked forward, one foot in front of the other, scared and all.

## Evolving

I didn't know it yet, but the shift wasn't just my job; it was also within my perspective and reaction to people and situations. As my opportunities and environment started to evolve to align with my purpose, so did I. I attended the inaugural Woman Evolve conference hosted by Sarah Jake Roberts in Denver, CO, and upon arriving, I immediately started to put up a bit of a wall; I felt it as soon as the figurative cement and bricks appeared. Initially, I didn't really understand the immediate change in my mood. The conference was life-changing, and the sessions forever left a positive imprint on my life. Yet, I used the plane ride back to really meditate and figure out why I had put up a wall, and the answer hit me like a ton of bricks using those same bricks from the wall I put up as a defense mechanism. The thought of building sisterhood with those outside of my existing sisterhood bonds made me so uncomfortable that my immediate response

was to go into defense mode. My response shocked me because I was so focused on my external shift that I didn't provide my internal shift enough attention.

That revelation made me reflect on a counterfeit mentor experience I had in college with a female campus administrator. Although years had passed, feelings of mistrust crept back into the picture at the conference, and that made me distrust other women who had the potential to serve in a mentor capacity in my life. I had to really sit and start another "innerview," and I asked myself the tough questions that needed answers and swiftly. Here I was in an environment full of empowerment and wisdom, but I was shuttering. I thought that I had fully moved past that situation of counterfeit mentorship, but that conference was the mirror I needed more than I even knew. It was an opportunity for me to go through any baggage that life had handed me and even bags that I handed myself. I've gained enough self-awareness to know when I am the culprit in comparison to others. While some outsiders may have provided the luggage, I take full responsibility for not recognizing the toxic contents and getting rid of them upon arrival. I had to face the music and learn that I have to handle the things that are within my control and within my authority to change, all while learning to let some things go.

Attending counseling was a great start to going through the baggage, but it was clear that there were still more bags laying around ready to be searched like a TSA agent examining luggage before an international flight. I am still learning that as life situations take place, it's our responsibility to control our reaction and to maintain enough awareness to know when we must inspect our luggage/baggage for any unwanted contents. An innerview isn't a one and done

type of luggage search; it's a continuous, ongoing process, especially when the direction of your life is onward and upward like an airplane at takeoff.

Traveling is one of my many passions because it provides me with exposure and cultural immersion. As with any trip that I've been on, my bags have had to be under a set weight limit, and there's a price to pay if the bags weigh more than the allowable weight. Some people on the flights may encounter a nice airline agent who waives the price, but if everyone on the flight has bags over the weight limit, the plane wouldn't be able to go to its destination or the excess weight may delay the trip. Our destination in leadership requires that we become self-aware at a higher level and that we become transparent in the areas that need healing. Therapy and innerviews can help us unload the baggage in healthy ways. It's in the quiet moments of self-reflection where we can ask ourselves the hard questions and become solution-oriented to make immediate long-lasting change. As we head to new dimensions personally, professionally, academically, spiritually, emotionally, and mentally, we must focus on making sure our baggage is free of any toxic words. Any negativity in our bag must adhere to a strictly enforced policy. Everything attached to us must look like where we're going and who we are evolving into.

As we evolve, we must remember that evolution is a continuous process in which we have to remain committed. For some, the commitment is reflected in regularly attending therapy. Whereas for others, the commitment is shown in intentionality in the company we keep and the steps we take toward finding and activating our purpose. Evolution and self-improvement are both marathons, not sprints. The work we complete behind the scenes of our successes and failures

allows us to perceive the outcome of those situations with a hopeful and optimistic lens that guides our growth toward purposeful work. Evolution and self-improvement can be activated with the help of the most trusted people in our inner circle that are willing to help us do the work necessary to thrive internally and as a leader.

# Innerview Questions

What upcoming shift are you anxiously anticipating?

How are you making smart financial decisions in preparation for the shift?

# Beyoncé Wasn't Built in a Day #SisterhoodGoals

---

*"As we grew closer, we decided to label our girl group. We couldn't help but to pick the cheesiest, most befitting name; we affectionately named ourselves the Golden Girls."*

One of the things I often reflect on is the power of relationships. Even when we see our favorite public figures, we know their success didn't just take place over night. I'm sure their relationships have helped them go from being good to great. For me, I often think about authentic mentors and friends who have left their stamp forever etched in my life and my heart. Valuable relationships are worth cherishing because they help correct us when we're wrong, they provide comfort when we feel like our world is crashing down, and they congratulate us when we've hit the mark of our desired success. In the same perspective of valuable relationships, ineffective and counterfeit relationships can cause us hurt like we've never seen before. I've been blessed to initially recognize amazing people and develop close connections with wonderful people who have shaped me as a woman on so many levels. One of those connections created my very own

version of the Golden Girls, which is made up of four Black women who are focused, driven, and God-fearing. It all started in Bloomington-Normal where I met Ariane (Ari), LaShawnda, and TaVashane' (TNae).

While attending Illinois State University (ISU) for my master's program, I encountered Ari, who was also in my program, and she and I just knew that we would be friends. We met for the first time during orientation week for graduate school, and we were the only Black women in our cohort. We were in a room full of our colleagues at a predominately white institution, and one by one, we stood up, introduced ourselves, and shared our research interests. When it was my turn, I introduced myself and shared that I was interested in possibly doing my thesis on the television show *A Different World*. I spoke with confidence even though I was beyond nervous. If you let Ari tell the story, this was when she knew we were meant to be friends. We were from the same city, and we eventually found out that we even had mutual friends.

That first semester of grad school, we were both in a small group communication class, and that's where we learned that we had so much in common. One day after class, we decided to grab food at a Mexican restaurant, and we bonded beyond belief. We laughed so much that we cried. We realized that we had so much in common, and from that point on, we started referring to each other as "life twins." Here was two normally private women sharing parts of their past and present circumstances with each other only after being acquainted for such a short time, but it was clearly a safe place. This was the start of a transparent friendship that pushed us into family territory as sisters.

I always tell the joke that she and I bonded because we thought we may have been dating the same guy. Yes, you read that correctly. Part of our conversation that night at dinner included our love lives, which both were in a bit of shambles because we were allowing ourselves to be attached to situations and people who had no part in our purpose and were doing more harm than good. She and I described our separate romantic situations with the guys we were dating there in town. I had known the guy that I was dating at that time since my teenage years. Oddly enough, Ari and I were saying the exact same thing, almost describing the exact same guy down to his physical appearance and personality. It wasn't until she said her guy's name that I put my head down because then she had even said the first name of the guy I was dating there in town. I was sure that she and I had just discovered that we were both being two-timed.

At that point, I felt like we would either continue bonding or start fighting if we felt like we were being played. I mustered up the strength to ask her for his last name because it was clear that we may have been talking about the same person. However, when she said his last name, I exhaled with relief that her guy and my guy had totally different last names. We laughed uncontrollably at the fact that we were too much alike, even down to dating guys with similar personalities and the same first name. Throughout graduate school, we supported each other academically, personally, professionally, and spiritually. To this day, she has my back, and I have hers.

A year after Ari and I met, our friendship circle expanded, and we met two other Black women in our graduate program who were just downright awesome: LaShawnda and TaVashane'. Ari and TNae already knew each other, but the four

of us bonded in a way that amazed us. We took turns having girl's night at each other's places, we took staycation trips just to unwind from the stress of graduate school, and we would check-in on each other whenever we weren't moving toward our goals like we knew we should. When school got stressful, we would pool together gas money and drive over to Champaign, IL, about 45 minutes away from campus, to go to the bigger mall where we would shop and grab food as our way of relaxing and bonding.

As we grew closer, we decided to label our girl group. We couldn't help but to pick the cheesiest, most befitting name; we affectionately named ourselves the Golden Girls. Currently, we are all knocking out our goals one by one because we have our fellow Golden Girls to help us stay motivated. We encourage one another to not make bad, life-altering decisions and to stay on track as much as possible, while also showing grace in moments of imperfection. These relationships are so dear to my heart because those ladies have been my rock in some of life's most difficult moments. Even as adults, my Golden Girls crew is still going strong. It's a blessing that we can be a safe place for each of us to be vulnerable and held accountable.

Luckily, LaShawnda and I were both accepted into the same communication program at the University of Missouri-Columbia, although LaShawnda is a year ahead of me in the program. My friendship with LaShawnda was strengthened because we were both in a new location where neither of us had family. When I met LaShawnda, I had no idea that some five years later, we would be close friends journeying to completion in our PhD program. When she and I met at ISU, I was a year ahead of her in the master's program, and a professor who

I had the year prior recommended that LaShawnda reach out to me for help in the class that she was having a hard time in. The professor figured that LaShawnda would benefit better from a fellow Black woman helping her improve her writing needed for the class, especially since I had that same struggle before making total academic improvement in that class.

However, the roles would completely become reversed when it came time for me to begin the PhD program at Mizzou. Since I had taken two years off after my master's program in order to work my corporate job, this meant that LaShawnda was in an earlier cohort of the PhD program, and she would show me the ropes as I did for her at ISU. To be able to work with my fellow Golden Girl and have taken doctoral classes with her just shows how much God is on my side. Her presence as a friend makes the PhD program feel more at home and helps me journey through the marathon of attaining the highest academic degree.

Relationship-building is so important because you never know when you'll have those full circle moments of relationships becoming integral to your life as you embark on new journeys and take advantage of new opportunities. A mentor or friend can become a lifeline as new dimensions of leadership require that you learn the expectations of success on new levels. Our divine connections with others help ease the tough times and stresses of the journey toward success. They provide laughter and encouragement when you just want to cry, lie down, and give up. They provide strength when you feel weak, weary, and tired.

I came across an article about a study done with 3,000 nurses who had been diagnosed with breast cancer. The study revealed that the nurses who had their own community of sisterhood were four times more likely to live through

their diagnosis. Four times more likely! Just by having a close-knit group of friends for support, our lives can be saved in critical medical emergencies. What about those moments that a doctor can't diagnose like a breakup, starting a business, moving to a new state, or even starting a new romantic relationship? These are all encounters where we need our tribe.

Relationships are pivotal to effective leadership, and having the right type of tribe is the equivalent of having a board of directors and secret service members. Your board of directors can see your vision, and they play a vital role in ensuring that you reach your goals. There's a level of selflessness within the directors that is mandatory as they serve in their roles. Like a board of directors, secret service members are protective of you and your goals. They refuse to watch self-destructive behavior that arises in the form of doubt, fear, and complacency. The right team can help our visionary leadership come to life, and they help protect us from ourselves and possible outside destruction. For me, the Golden Girls are part of my secret service, and a few of the Golden Girls are on my board of directors. I'm a better leader because of the role and value of my relationships as they pertain to my goals as a leader and my growth as a woman.

Yet, it's one thing to recognize, embrace, and allow these relationships to take place. It's another thing to value, cultivate, and even vocalize your appreciation for these relationships. We can't forget that not all connections will last forever; some will only be for a season, but that's where wisdom and discernment come in to help us identify the expiration date on some connections. In the meantime, let's build our tribe and make our goals a reality. Greatness is a team effort!

# Innerview Questions

What value does your current friendships/friend group add to your goals?

Which of your friendships are currently past their expiration date?

# Don't Push Me Cause I'm Close to the Edge

---

"Counseling was a safe place to reveal that I was
overworking myself for years to avoid having free time so
that I wasn't left alone with my own thoughts and feelings of
loneliness without my mom."

Many of us can relate to experiencing some frustration with a work or leadership position when we are ready to go to the next level. Whether it's leaving the toxic work environment for the job that we know we're qualified for or moving beyond the leadership role in a campus organization that we have outgrown, that frustration can become dangerous if we don't spend our waiting time preparing for the next move. When I was working in corporate and was beyond ready to quit my job, I knew that I couldn't just quit; I had to take the time to prepare my exit. Preparation was more than just saving money and building up my speaking business; it involved ensuring that I was mentally at peace despite challenging past or present situations. In particular, I spent time asking myself what I needed to do holistically to move to the next level. Of course, the answer was

none other than counseling. That was one of the missing components needed to complete my preparation of exiting one level and entering another. I had to be ready to enter into this new level of leadership with an improved mindset and a reality of wholeness, which would take a new level of innerviews to do the root work needed.

With the help of counseling, I realized that I hadn't allowed myself to properly grieve the loss of my mom. Then I realized that my need to grieve was for more than just the loss of my mom; it was also the grief of my old life that was dismantled when I had to move back to Chicago, leave old classmates, and move into my grandmother's house. It wasn't just my mom that I lost. It was also the instant separation from the life that I had grown accustomed to living. There were various life experiences and situations that I needed to sift through and analyze to see the connection and impact her death had on other points in my life. What started as grief counseling turned into an opportunity for me to increase my self-awareness and talk about the life experiences that I needed to release. Counseling evolved into a chance for me to be more transparent by talking about all my amazing and also downright horrible life experiences, and it became so essential and valuable for me that I continued the journey beyond discussing my grief. My sessions also included examining other familial relationships and friendships, exploring my deepest fears, and evaluating how I showed up in my relationships.

I found joy in no longer having to hold things in. Counseling was a safe place to reveal that I was overworking myself for years to avoid having free time so that I wasn't left alone with my own thoughts and feelings of loneliness without my mom. The loss of my mom, even years after her death, had me feeling like

something in my life was missing just like the analogy I gave in a previous chapter of accidentally leaving a cellphone at home. Situational depression would arise, and it became harder to hide it from those closest to me. My counselor helped me get to the root of my work addiction and hidden grief, and the next step was for her to help me put together a tangible plan that would help me sift through my thoughts and emotions and not be afraid to face those things. Counseling saved my life by helping me create an activation plan that stopped me from living a life where I was overworked. The beauty of seeking help for mental wealth was going from awareness provided by innerviews to actual activation of learning outcomes.

My counselor was a Black woman who shared my spiritual faith, so that became a component of our conversations and activities. She talked with me about my deepest fears and how those fears manifested through the barriers I put up in my relationships with others as a defense mechanism. I realized that the defense was in place as a way to avoid ever going through the tragedy of losing people I cared for. I pinpointed the relationships where I used this defense mechanism, and my next step was making the personal changes I needed to remove those barriers. I exposed and gutted my fears so that they would no longer run my life. Even now, I've made tremendous progress with the barriers, and instead of building a barrier made from bricks of fear, I use wallpaper backed with caution. The wallpaper represents some form of protective mechanism, but it's not impossible to break through.

I had no idea how freeing and exhilarating counseling would be, and having my counselor sit across from me and just listen was like finding gold. Counseling became my healthy outlet to voice my concerns or ideas all while being intentional

about being the best version of myself. I was making progress, and I could see the change within myself. I could feel the burdens lift, and I was happy to see my own journey of transformation. My personal improvement wasn't just for me; it was for the thousands of people who I will continue to empower, motivate, and inspire. This step was about getting to a level of wholeness that would birth the transparency and self-awareness needed to make me a better speaker, sister, friend, mentor, and leader.

Counseling was never anything that I was ashamed of, and I would even bring it up in conversations. I am always excited to share with others what has helped me tremendously. Because of my positive experience with counseling, a few of my friends decided to also partake in counseling based on our conversations and my recommendations. I'm sure much of it was based on those friends having a front row seat to how I operated in the past and the progress that I've made to get to my current state. One conversation over breakfast and girl talk led to LaShawnda, one of my fellow Golden Girls, seeking counseling for her own healing.

The Golden Girls and I went to a Chicago breakfast spot, STACKED, that was famous for its red velvet pancakes. We were all spread out across the Midwest, so we were overdue for a face-to-face meet up. We had so much to catch up on that we sat down and immediately went around the table giving life updates that reflected our lives post-master's degree. TNae moved home to Chicago, had just started her first fulltime job, and was teaching college classes on the side. Ari had also moved home to Chicago, was months into her first fulltime job, and was expanding her entrepreneurship endeavor with an event planning business.

LaShawnda moved to Missouri and was in graduate school for her PhD, and she mentioned some of the difficulties she was having with her family. I was still living in Bloomington, IL working my corporate job and teaching on the side.

When it was time for me to share my updates, I talked about my upcoming exit from my job and my life-changing experience with counseling. Before I knew it, we were all discussing the benefits of counseling, and I was quoting crafty lines as if I was Shakespeare mixed with Socrates. At one point during the conversation, I said, "A plane that is headed in the direction of its purpose can't take off if the weight of the baggage is too great." Little did I know, that quote pierced the heart of LaShawnda, who was really struggling with her family relationships. It wasn't the quote that stung her, but it was the wound of the past issues that she had never faced and was still holding onto. She began counseling soon after our Golden Girls brunch, and the change in her was evident. She began to release her past experiences, make connections to her dispositions, and seek out areas of improvement. She moved past negative generational cycles just by examining and naming her pain so that it no longer held power over her.

I cherished the chance to watch my friend grow as I was growing and glowing through life's difficulties. I was so happy to see us all headed into our future without the weight of our past. I had no idea that my journey of wholeness and self-improvement would impact the lives of those around me, and the speaking, mentoring, and counseling all had a bigger impact than I could've imagined. It's all bigger than me, and my steps are ordered not just for me but to be used to reach the masses. My healing has restored my heart and my ability to share my story.

In August 2017, I spoke at IMPACT, a freshman orientation leadership event at my alma mater, Central Michigan University, and I told the story of losing my mom. After my presentation, a young woman came up to me and said that she, too, had lost her mom at a young age. She revealed that hearing my story was the motivation she needed to know that she can also pursue her goals successfully while in college. In that moment, I knew that I had to continue the process of overcoming any fears or life experiences that left any emotional scars.

True leadership provides realism and action simultaneously. It's the part of leadership that sees a problem and immediately looks for a solution, even if that solution stems from you innerviewing yourself to see what you need in order to be the best whole version of yourself. Don't just acknowledge that a problem exists without implementing a solution. Don't just have awareness without proper activation. Complaining and being complacent may be easier for some, but it's definitely not a healthy habit of successful leaders.

I charge us all to examine our lives and pinpoint some key areas that happen to consistently find their way into the forefront of our minds. What are some issues that you haven't let go of even though the situation has been dead for years? Who are some of the people who have exited your life, whether through death or free will, who you've never let go of mentally and emotionally? It's deep stuff for sure! You can't heal what you don't reveal, and it's hard to lead others when you find yourself at the edge of overwhelmingness when you probably should be on the edge of the couch of a mental health professional.

# Innerview Questions

How can you benefit personally from counseling?

How would counseling impact you as a leader?

# Timing Makes the Difference

---

"If you are in the limelight as a leader, these authentic mentors care about the person you are when the lights are dim. They are committed to you being stainless when the lights are bright, and that stainlessness only comes if you are committed to being transparent and humble enough to accept correction and wisdom."

I'm from the South Side of Chicago, so whenever I go home, I have to go to my favorite restaurant, Home of the Hoagie; this place only takes cash, is one way in and one way out, and has armed security at the door. Every time I go, I stay on high alert, I keep my eyes open, and I scan the place about a million miles a minute while standing in line. The neighborhood is a bit rough, and as someone who grew up on the South Side, I know to be watchful of my surroundings, and I use that same observant behavior when I reach new life-changing levels and make new influential connections along the way.

When I enter new leadership environments, I like to see who's there and how I can learn more from them and their experience. Being observant is about more than just paying attention to the environment where we're leading. More

importantly, it's about paying attention to the timing of your leadership and the areas where you know you're about to experience a shift. It's about having a team around you that is also mindful of timing and ready to take advantage of new opportunities as well. Some opportunities that may seem amazing can be negatively life-altering if activated at the wrong time in our lives. We need people around us who can help us recognize the right opportunity at the right time.

I mentioned earlier that when I finished graduate school, I stayed in Bloomington, IL, for two years afterward to work my corporate job. While working there, I realized that a lot of the people who worked for the company had been there for at least 20-30 years with no plans of leaving until retirement. Bloomington is the perfect place to raise a family; it's so popular that many people even retire there. However, it can be a rough town to live in for a young professional who doesn't have a husband and kids yet. Especially for young professionals who want to enjoy the weekends with good social events and a thriving nightlife where they can enjoy the fun and company of other young people. What I wanted was everything that I was missing by living in that town.

Even with a professional life that was thriving from a financial standpoint, living in Bloomington was still rough for me. It was tough living there alone without my core group of friends and family. At that point in my life, it was pretty difficult to live there because I was about two hours away from home and many of my friends, including the Golden Girls, who had all moved away after graduation. So here I was getting up and going into work every day when I realized that my happiness had got up and walked away months ago. I started having heavy feelings of loneliness and wanted out of Bloomington quicker than I could blink.

As soon as I felt those feelings of escape, I met Chequita.

Chequita (Che) was one of the ministers of the church I joined in Bloomington. What I appreciated about the church was the strong women's ministry and the community within the household of faith. When Che and I first met, I was emotionally drained, and it was written all over my face; I felt like I was wearing my discontent of my current circumstances. There were times when I felt as if I was just dragging along trying to make it. I despised my job, and that made living in Bloomington much more difficult. Over time, she and I became close, and I deemed her to be one of my spiritual mentors. Her faith was unshakeable, and her spirit was authentic and genuine. She became like my older sister, and I believe she is someone who was divinely placed in my life to help me grow personally and spiritually before my transition. She was one of the coaches placed in my life to help me train for whatever the next level of my marathon would be. I once prided myself on being closed off and private, and I never really allowed too many people to see me vulnerable. But it was clear that God had a plan as He continued to place people in my life who debunked that theory of extreme introversion that I had once built my personality on.

Che kept me encouraged and even held me accountable. She was someone who clearly had my best interest at heart, and the more I reflect on our bond, I become even more appreciative. That very same tribe of board of directors and secret service members that is comprised of the Golden Girls, also includes Che and other God-given additions. These additions made sure that I wasn't only prepared to handle the pursuit of purpose but that I was also ready to handle all that came with purpose work.

It was no secret that I was planning to run like the wind from my job and Bloomington, but Che made sure that I was aware of when it was the right time to begin executing my plan. I knew that I didn't want to move outside of what was clearly God's will for my life, so I had to stay put until it was time to shift. I did what was necessary to decrease any feelings of anxiousness and stay content in my current environment. I focused on going to the gym, working on my speaking business, and making the most of my time in Bloomington. This contentment granted me the biggest blessing wrapped in disguise. It grew my faith and exposed me to my passion, purpose, and calling.

This mentor relationship with Che was a divine connection that has shifted my life and showed me the importance of being open with my mentees. To date, Che has provided me with some of the most brutally honest advice, even down to any issues in my love life. Her commitment to my growth has only made me appreciate her genuineness time and time again, while also renewing my faith in mentors. When it came to advice about dating, she made sure that I never forgot my self-worth, even when I would gush at how attractive a guy may have been. She gave me constant reminders to remember my values and to set healthy boundaries. No matter how great of a leader you may be, it's essential to have someone to submit parts of your leadership to so that they can provide wisdom, direction, and healthy accountability. If you are in the limelight as a leader, these authentic mentors care about the person you are when the lights are dim. They are committed to you being stainless when the lights are bright, and that stainlessness only comes if you are committed to being transparent and humble enough to accept correction and wisdom.

Who are you willing to submit parts of your life to in the most genuine, transparent, and accountable way? Submission is about being open and honest with another person and creating room for accountability. That accountability can be found within our finances, romantic relationships, professional careers, entrepreneurial endeavors, social lives, and even our physical fitness. It's about having a team of people who are trustworthy enough for us to reveal our goals, then allowing those people to help hold us accountable to sensible actions that push us toward successfully achieving our goals.

How often do we recognize those angels in our lives who want nothing more but to see us be everything that they know we can be? How often do we thank them for their countless hours of wisdom, comfort, familial love, direction, and correction? If I've learned nothing else, it's that angels away from home exist, and it's important that we show our appreciation and pay it forward by imparting wisdom onto others as well. As a leader, I understand that I don't know everything, but I am willing to keep a team of wise counselors around me to help guide me.

# Innerview Questions

Who are you able to be your truest self around?

How often do you show appreciation to those who allow you to be your truest self?

# It Was All a Dream in a Different World

"It was in that moment when I realized that I had unlocked something special. Speaking and touching the lives of others was more than something I was good at; it was part of my purpose and calling."

D reaming takes a level of vision that goes beyond present circumstances. Sometimes the fulfillment of those dreams inches us closer to our purpose and unlocks one of the many things that we were destined to complete. The fulfillment of our dreams helps us to start legacy work with the purest intentions while learning more about ourselves along the way.

During my life in Bloomington, I realized my passion for speaking through a unique, dream-fulfilled experience. When I was wrapping up graduate school, I completed my master's thesis on my favorite television show, *A Different World*. In the 7th grade, I remember watching *A Different World* and *Saved By the Bell* back-to-back before leaving to catch the school bus to school. I loved *A Different World* so much that I would always tell my mom that I was going to attend Hillman College,

the fictitious historically black college/university (HBCU) in the show. On my first day of my master's orientation, I declared that I would use the show as the foundation of my thesis.

I had heard about an upperclassman in the program who was also using a pop culture television show, *Orange is the New Black*, as the main piece to his thesis, so I set out to meet him. I dropped any fear I had, and I vocalized my interest in learning more about the process that my classmate was using to write his thesis. I was surprised that he was willing to show me his blueprint on how he was able to craft such a unique piece. He allowed me to have multiple, pretty much unlimited, conversations on the steps that I could take to execute the same type of written work. He went as far to explain to me the makeup of his thesis committee with an explanation as to the value that each professor added to his writing process. After our many chats, I realized that I had struck gold by seeking wise counsel in his wisdom and experience. That knowledge from him was all that I needed to spark my creative process, and I decided to focus my thesis on the communicative relationships between three characters from *A Different World*: Ron, Dwayne, and Whitley. That's just a fancy way of saying that I looked at how the brotherhood between Dwayne and Ron and the romantic relationship between Dwayne and Whitley were impacted by how they communicated, who they were, and any issues that arose based on that communication.

For eight months, I found my writing groove all while working two jobs, being a full-time graduate student, and being a millennial, traveling and enjoying life. Since the show was more than 20 years old, I couldn't get my hands on the show's scripts for each episode, not even for the 10 episodes that I was using. So

that meant that I had to transcribe each of the 10 episodes by myself, without a paid service or the help of my friends. Don't judge me, but I had the time of my life watching those episodes and typing every word that the characters said. This level of joy was evidence that the show had a deeper meaning in my life, but I still hadn't quite figured out what that meaning was. So, I kept writing.

After eight months, I wrapped up the thesis, and it was time to defend it in front of my committee made up of the four smartest professors I had ever encountered. The week of my scheduled defense, people tagged me continuously in a promotional flyer showing that the cast of *A Different World* would be at an event at Norfolk State University (NSU), a HBCU in Virginia. The last straw was when my sister texted me a copy of the flyer and asked had I heard about the event. I don't believe in too many coincidences, so I contemplated traveling to Virginia to attend the event. But I quickly dismissed the thought, thanked my sister for sending me the flyer, and joked about how many people sent it to me as well.

The day of my thesis defense had finally arrived, and I was nervous beyond belief because a defense could make or break your graduation plans. There is no graduating with a master's degree if the thesis isn't approved by the committee, so my heart was racing the entire morning. As I headed to campus, I called my Auntie Dee Dee to voice my nervousness, and as any auntie does, she provided me with some encouraging words and jokes and helped me kick down the door of fear. She encouraged me to continue to do what I know I was called to do. Before getting off the phone with her, I mentioned the flyer for the *A Different World* event and gave her the details of the event. Immediately, my auntie told me to get off the phone with her and to call NSU's sponsoring office of the event and explain who

I was and my connection to the show in hopes of convincing them to allow me to meet the cast. As an adult, my aunt is a friend and a leader who I respect; she disciplined me as kid, and in that moment, the tone of her voice was that of a disciplinarian who meant business. Even as an adult, I followed her directions and remembered her words, "The worse they can tell you is no."

I called the sponsoring office's number that was listed on the flyer and explained who I was and my connection to the show, and I let the university representative know that I was actually headed to defend my 130- page thesis on the show. At first, the woman thanked me for my interest in attending the event's meet and greet, then she told me that the meet and greet was only for those invited by the sponsors. Immediately, my heart dropped, but I remembered that my mom had taught me to never give up on something I believed in. I pretty much pleaded with the representative to let me come to the meet and greet. I explained my personal story and connection to the show, and I even let the woman know that although I was a graduate student living off of my $1000 a month assistantship stipend, I was willing to pay for my travel costs to attend the event. I could tell she heard the passion and desperation in my voice, and I saw a glimmer of hope. She agreed to let me attend but under one condition: I had to send her a one-page letter detailing why I thought that the sponsoring office and related outside sponsors should allow me to attend the meet and greet with the show's cast. I got the details for where to send the letter, then I thanked the representative before ending our call.

Before I could focus on the letter, I had to get my mind right to defend my thesis. When I walked into the room, my heart warmed at seeing my grad

school friends who were attending the defense and brought me flowers and cards. Saying that I was excited and overwhelmed with gratitude was probably an understatement. After I successfully defended my thesis, I went straight home and wrote the best one-pager ever directly from my heart. I crafted the letter so quickly that I had enough time to ask one of my grad school colleagues to review the letter to make sure it made sense and flowed. After working on the letter for about two hours, I emailed it over to the representative at NSU, and she promptly sent my letter over to the event sponsors. They were impressed with my story and agreed to have me attend their meet and greet, which was about two weeks away.

This lesson let me know that there's true power in telling our stories from a place of authenticity. Our stories and our gifts will continue to make room for us as leaders. Leadership isn't about moseying around timidly; it's about finding the strength to advocate unapologetically on your behalf. As we progress in life, we have to find our voices and never lose them. Finding your voice is part of the maturity that allows you to step up and speak up when necessary. Our voice is the vehicle to speak with power, authority, and uninterrupted confidence. When we lack confidence, that's the perfect time for our tribe to provide us with the batteries we need to recharge our confidence. However, we have to be transparent enough to speak up and admit when we are lacking confidence and when we need our community to provide some words of wisdom to re-energize us as we run our race.

The next day, I got an email from a someone saying that the *Steve Harvey* show was looking for college students with a communications background to be on the show and ask Steve Harvey a question related to college. As a proud South

Side Chicago native with an eye for what seems like schemes, I was sure that this was a scam, and I immediately deleted the email. A day later, I received a phone call from a *Steve Harvey* show representative, and he assured me that his email wasn't a scam. My aunt looked into it too, and she also assured me it wasn't a scam and even offered to accompany me to the taping.

On the day of the taping, I arrived at the NBC Chicago building with my aunt and was greeted by a representative who showed me to a dressing room with my name on the door, a hair and makeup stylist, and a stocked refrigerator. Again, my South Side upbringing mixed with common sense kept telling me that something was up, but I just thought that maybe I would win a car like on the *Oprah* show. Plus, my aunt had been acting weird all day, but I just brushed it all off and prepared myself to ask Steve Harvey the cheesiest question about his take on college. I was happy to get all dressed up and experience whatever was about to come my way. I had found a deep orange dress at Express on the clearance rack, and I paired it with a taupe jacket from TJ Maxx and some light brown heels from Old Navy. It's safe to say that I was pretty stylish. While in the dressing room, one of the staff members came in to get my dress so that they could steam it to remove any wrinkles.

My brain stopped working for a quick second when the staffer asked for my dress because I had the actual dress on. I told him that if I'm wearing the dress then giving him the dress would mean that I would be unclothed. He laughed, said that they were going to give me a robe, and joked that "this isn't the *Jerry Springer* show." In other words, I had nothing to worry about. That's how nervous I was;

I couldn't even think clearly when figuring out how to get situated with my dress being steamed.

After awhile, the time came for my aunt and me to walk to the set to take our seats. Much to my surprise, I saw huge pictures of the *A Different World* cast lined up across the set. I became confused, and I stopped in my tracks, turned around, and looked at my aunt to try and figure out what was really going on. Suddenly, it hit me like a ton of bricks. I wasn't there to ask Steve Harvey a question; instead, they were surprising me with the chance to meet the cast because of my thesis. I wasn't even sure how they knew about the thesis that I had just defended only days prior.

Immediately, I started to hyperventilate, and my hands were shaking. Then, I started to weep uncontrollably, and I crouched down and balled my eyes out. All of my hard work had come to fruition in a way that I would've never imagined. I cried not just because of the chance to meet the cast but also because I felt like I had walked into a room and saw my mom. The *A Different World* show was a connection that my mom and I had shared. I was crying so hard that the producers thought they were going to need to call the paramedics, and I wouldn't be able to film since I was hysteric. But fear not, I was able to get it together after a short praise break, and I got to my seat and was ready for my time with my favorite life-changing show.

Opportunities can arrive at the most unexpected times, and magic happens when opportunity meets preparation. The opportunity to display my research and passion project on the *Steve Harvey* show was a dream come true, and because I was prepared to walk in that blessing, the magic was me meeting the cast who

showed me the possibilities of attending college. That moment unknowingly unlocked my passion and was accompanied by a multitude of life lessons. "You never know who's watching," is something I learned rather quickly. Unbeknownst to me, one of the NSU event sponsors was responsible for setting up the *A Different World* cast to film a segment on the *Steve Harvey* show. A man who I hadn't met previously would be the angel who shifted my life and helped bring me closer to my purpose.

After taping the *Steve Harvey* show, I had to sit on that secret for a month since I signed a contract saying I wouldn't publicly talk about my appearance on the show until the producers provided me with an air date. A week after filming, I went to the event at Norfolk State University, and I got to meet the university representative and event sponsors and thank them for everything.

---

Once I graduated with my master's degree, my alma mater, Central Michigan University, reached out to me and asked if I would keynote their freshman orientation leadership program. They wanted me to incorporate my past leadership experience at CMU and my recent *A Different World* experience from a few months prior. It wasn't rare for me to speak at CMU because it was something that I actually enjoyed, but much to my surprise, they were going to pay me this time for speaking. I was surprised because speaking at CMU was something I had done for free a few times before. Of course, I agreed to speak at that event, and I

prepared my presentation and spoke at the event in front of about 300 people, including some of my family members who were there to support me.

After my presentation, I had lines of people waiting to talk to me. It was in that moment when I realized that I had unlocked something special. Speaking and touching the lives of others was more than just something I was good at; it was part of my purpose and calling. That speaking engagement opened the door for my future and inspired me to seek opportunities where I could learn the business side of speaking.

Weeks after that event at CMU, I went back and forth with myself on the idea of being a professional speaker, and I talked myself out of it daily. One day I was listening to a few of T.D. Jakes's sermons, and they all seemed to mention how people were given God-given talents and not using them meant that we weren't fulfilling part of the purpose predestined for us. While listening to some his sermons, I felt convicted, and I decided to push past the fear and walk in the calling of speaking. I wasn't convicted as in arrested but convicted as in what happens when you're not fulfilling what it is that you know you are called to do. I had to get out of my own way, be willing to be selfless, and lead without fear.

Take a few seconds and think of what it is that you know, without a shadow of a doubt, that you are called to do. If you're not quite sure of the answer to that, then think about what solution your skill set provides to others' problems? We all have some form of gifts and talents, but they are often dormant until some exploration and experiences allow them to become visible. All it takes is for someone to recognize the potential in our abilities to set our passion ablaze.

# Innerview Questions

What do you believe you were called to do?

What type of confirmation have you received on this calling?

# Discipline with the Help of Santa Claus

"Natilie, you can finish this race, and I came back to help you. I refuse to let you quit because I know that you can do this, no matter how hard it may feel. Just keep running. You're almost done."

Every climb toward a new dimension of leadership requires an updated amount of discipline. The requirements of work and leadership don't diminish when you go from leading a small group at work to managing an entire team or when you go from being just a member of a campus organization to the president. Instead, you have more responsibilities, and you need to enact even more focus and balance with yourself and the role of leadership. However, be careful that the balance doesn't become unequal by placing too much focus on one area versus another. Too much focus on ourselves means that we may do a disservice to those we lead and the topic in which we're leading. Too much focus on our leadership responsibilities can mean that we are doing ourselves a disservice. Balance and prioritization allow us to be effective leaders with growing

discipline, and they allow us to be leaders who are dedicated to growing the discipline of leadership.

Shortly after my *A Different World* experience and my speaking engagement at CMU, I stopped to reflect on a picture I had taken with my grandmother after the event. My grandmother and my aunt accompanied me to the speaking engagement and my granny was as happy as could be. When I was going through the pictures from that day, I looked at one picture with tears in my eyes, and they weren't tears of joy. Instead, they were tears of disappointment. Although I was flourishing academically, personally, and professionally, I was failing miserably with my physical fitness. The picture showed how much weight I had gain with the weight evident all in my face. I had ballooned to 203 pounds, and that very moment was an indication that I was missing balance in life. My health wasn't much of a priority for me, but it wasn't because of my eating habits; it was because of my lack of physical activity.

I once read a CNN article that said sitting for long periods of time was the equivalent of smoking cigarettes. My lack of exercise meant that, figuratively, I had been smoking multiple packs of cigarettes a week. Looking at that picture was all the proof and motivation I needed to find a way to get into working out and enjoying it. I felt like my life literally depended on it. I knew that my mom died from a heart attack and that my dad has fought his own share of health issues, including cancer, so it was clear that I needed to make a change before it was too late. I decided to pick up kickboxing with a friend of a mutual friend, Maria, who was the best friend of a girl I went to college with. So Maria and I connected and befriend each other, and together we joined a 12-week kickboxing program at

Farrell's gym. For three months straight, we attended classes until we completed the program. After the 12 weeks had ended, we extended our fitness membership an extra three months.

When I first started the program, I encountered a man who showed me a kindness that touched my heart beyond belief. I refer to him as Santa Claus. Yes, the same fictional character who many of us grew up believing in; the same man who has white hair, a deep hearty voice, and the heart that supplies unlimited gifts all around the world. I like to say that I actually met Santa Claus live and in the flesh during my time in the kickboxing program. Just listen. I promise you'll understand my real-life experience.

When Maria and I initially signed up for the kickboxing program, we found out that they make you take a fitness assessment at the beginning, middle, and end so that you can see your progress and know that the program was working. One of the tasks they had us complete was running one mile with a timer. I was pumped and ready to knock out the mile run, but reality kicked in after I finished the first half of the mile. I started to get tired and out of breath, and I wanted nothing more than to sit it out. To pace myself, I slowed down and continued to jog toward the finish line. Some of the other runners passed me, but there were still others behind me, which helped me maintain a bit of confidence in my run. As the finish line neared, I started struggling, and it was clear that I was about five seconds from stopping for a prolonged period of time to catch my breath. My cute workout clothes were doing nothing for me with this run. The same heart that I've shown when facing difficulty in life was the same heart that I needed then to push past my physical fatigue.

What I didn't know was that the man who I had made small talk with before the run, who I affectionately named Santa Claus, would be my saving grace for finishing the run. I call him Santa Claus because he had that exact same bright white hair on his head and a full beard and mustache. The only difference between him and the fictional character was that this guy wasn't new to working out consistently; he had muscles all down his arms. Before we started the run, I happened to be sitting next to Santa Claus who was clearly already in shape and in charge of his fitness. I made small talk trying to be friendly, and during the conversation, he mentioned that he was in the process of training for an upcoming marathon; the kickboxing program was just one way for him to get in the motion of running. I was impressed that he was being intentional about preparing for his own goal execution. So, while I was lacking the strength to keep up with the last bit of the run, Santa Claus had finished the race and was at the finish line clapping and motivating everyone who was still trying to finish up. This man had completed his difficult task, and instead of going back inside the building to grab his belongings and leave, he decided that he would stay to encourage others who were still running the race.

By the time I was 60% done with running my mile, my energy level was on zero. I felt like a dimly lit candle sitting by an open window or hard-blowing fan. However, I knew that quitting wasn't a realistic option, even though I had already imagined myself just stopping and calling the rest of the mile run quits. Then, Santa Claus did something I wasn't expecting: he left the finish line, and it wasn't to go inside and grab his belongings. He was no longer clapping and yelling to tell people that they could finish. Instead, when I looked up, Santa Claus was right by my side,

on my right side to be exact. He saw how much I was struggling, so he called me by name, came to my side, and told me some encouraging words that brought tears to my eyes and joy to my heart.

Santa Claus told me, "Natilie, you can finish this race, and I came back to help you. I refuse to let you quit because I know that you can do this, no matter how hard it may feel. Just keep running. You're almost done." After hearing those words, I knew that I couldn't just quit. I slowed my pace, but I didn't change the destination. I reached the finish line, or shall I say, we reached the finish line. Santa Claus made it to the end with me, and I have him to thank for not letting me quit or take an easy way out. How many of us would turn around and head back into the proverbial race to help someone who hasn't quite finished, even after reaching our own goal or executing our vision? That level of selflessness can impact a life more than we could ever imagine. That level of empathy could be the push that person needs to finish their race and to then turn around to provide that same level of help and love to someone else.

During that kickboxing program, I learned more than just to enjoy working out and pushing myself; I learned discipline. After the six-month program was over, I figured that I no longer needed the group setting for my fitness success to take place, so I continued my journey in the confines of a regular gym. With a franchise gym literally a step away from my apartment, I had no excuses. The gym was so close to my apartment that we shared the same parking lot. Every morning, I would wake up at 5am and run a mile or two at the gym before heading off to work. Maintaining this journey, I lost 25 pounds and was in the best health of my life, including mental, physical, emotional, financial, and spiritual health.

The discipline that I gained from working out trickled into just about every area of my life, and I learned the balance necessary for prioritizing my success. Little did I know, having a fitness regimen was essential for traveling the country every weekend and prioritizing my time and activities. It also helped me prepare for my shift, especially as I began to ease into the routine of simultaneously maintaining three careers.

Whenever people ask me how I maintain such a demanding schedule, I often reply that it's all thanks to my faith, focus, discipline, and memories of my dear friend Santa Claus. This isn't to say that my discipline doesn't falter at times, but my experience with Santa Claus is an embedded memory that I can recall when I find myself needing to restructure my focus and discipline from a leadership, physical, and even emotional standpoint. We all need our own Santa Clause to help us survive and improve.

# Innerview Questions

Who has been your Santa Claus on your journey of leadership?

How have you prioritized your physical health as a leader?

# Community for Survival

---

"What if John had a genuine community who could have interceded on his behalf when any life issues started to take a toll on his health? Having a small community could have been some aspect of his survival."

A friend once told me that my life should be a movie. I couldn't help but laugh even though I completely agree that my life is full of random, yet full-circle moments. However, the leader in me is able to pull a life lesson from almost anything, including the importance of community and what happens when a community is absent. This lesson came during my last year of my master's program at Illinois State University.

One day I came home to my apartment to find a foul smell in my building. It was during the week of Fall semester final exams, and it was a brutal winter season. I immediately chalked the smell up to someone had forgotten to take their trash out. Since it was wintertime in the Midwest, which meant it was extremely cold, the leasing office heated the building, and that heat magnified the smell to the point that years later, I can still recall the smell. For about two to three days, day after day, I came home to the smell, which was magnifying each day. That last

encounter with the smell was all the evidence I needed to know that it wasn't the scent of trash that had continued to saturate the building. I went into my apartment to catch up on my favorite television show, and after I turned on the heat and wrapped myself in my blanket, the smell came through my vents at full force. It was clear that the smell was coming from the apartment below me, and it wasn't trash.

That next morning, I drove to the leasing office to report the smell, and the best description I could give them was that it smelled as if something was dead, rotting, or decomposing. I assumed that the office would think that I was overexaggerating and wouldn't pay much attention to my claim. On the contrary, they immediately called the police, and the police instantly recognized the smell. It was the smell of death. The man who lived below me, John, had been dead in his apartment for more than a week. They believed he passed away from natural causes, and he didn't have any friends or family in town. His mom lived in another state and was paying his rent. Sadly, no one was around to frequently check in on John to make sure he was okay. There was no one to realize that they hadn't heard from him in a few days or to do a welfare check.

His death was only discovered because I had enough sense to report the odor. I found out that I was the only person in the entire building to report the smell. That meant that I was the only person with enough interest in the security of my home to actually say something. Rest assured that I quickly moved from the building after learning that no one else in the building complained about the smell of death even before we knew exactly what it was. I moved because it was clear

that the neighbors didn't care enough to pay attention to a crisis right next door, and the thought of John's dead body was more than I could handle.

Days after, his apartment and parts of the building were fumigated. New carpet was placed down, fresh paint was thrown on the walls, and new tenants were moved in as if the deceased former tenant was never present. My heart ached when I realized that John probably didn't have any mentors or mentees who were in frequent enough communication with him. If he had someone close, going days without communication would have prompted some action. Of course, there are some parts of life that we are meant to experience and endure by ourselves. However, there are also parts of life that we can only overcome by the assistance and presence of our community. What if John had a genuine community who could've interceded on his behalf when any issues started to take a toll on his health? Having a small community could have been some aspect of his survival. I wonder how different his life would have been had he had his own Santa Claus or his own version of the Golden Girls.

No matter how great we may appear to others, having a community is equally as important as our accomplishments. The presence of a community is the added encouragement we need to go further and work harder than we could initially imagine. However, if I've learned nothing else, I've come to learn that not all community members are permanent fixtures in our lives; some are surely seasonal, and that is perfectly alright.

My lifestyle of leadership remains powerful because of the strong personal and professional relationships in my life. As leaders, we must know that good relationships help keep us going by offering encouragement and constructive

feedback at each new dimension or level of leadership. Relationships are the one thing that we should always cultivate like a plant in a healthy environment.

On the other hand, being seen as a solution in the eyes of others can be both a blessing as a curse. It feels good to know that as a leader, we're perceived to have enough wisdom and work ethic to be of value and assistance to others. However, we have to be careful as to not find ourselves suffering from burnout as a result of being consistently available for the needs of others. It can be tiring and heavy when you're always pouring into others on a consistent basis. Who do leaders run to when they are always looked to for the answer? It reminds me of a quote that Brian, my friend from high school, once said, "Who encourages the encourager?" The resolution for circumventing burnout is to balance how much you allow yourself to be available to others.

Our inner circle, secret service, and board of directors can be the essential community that helps us survive in the world of expectations and high work ethic. Our personal and professional relationships can be the source of encouragement that we need, especially as we grow as leaders with more responsibility. Community can be a source of reality because the life of leading isn't glamorous even though social media will swear that it's all roses and gold lilies. Professional relationships are like a manual with the steps to get to your next level, and they can assist you with achieving those goals by way of connections and mentorship.

## Counterfeit Mentors

Mentors can be physical mentors who open up their experiences, hearts, and minds to those who are willing and desiring to learn more. Or they can be

virtual mentors who may not even know you exist, but you have admired their work from afar and have used technology and social media to learn more about their path to leadership. As Tony Robbins says, "Success leaves clues." In this day and age, it's not too hard to research the process behind someone's success. That's the beauty of this high-tech age with everything at our fingertips.

Mentors should have three key components before mentoring anyone: heart, experience, and intention. If just one of those components is missing, it could be catastrophic. Beware when seeking mentorship because not all people with experience should be your mentor. The experience just says that the person has already taken the path that you're interested in, whether they are currently en route on the journey or they've completed it successfully. You'll come across some people who have enough experience to wow you and make you want to learn more, but if that person is lacking the heart to lead others, that mentor relationship could do more harm than good. I've actually seen this happen and had a bit of experience with this in my own life back in college. I've had a firsthand look and connection with someone whose credentials made them appear to be the perfect mentor, and she even made herself appear to have the heart and intentionality for mentoring others. I mentioned this experience briefly in a previous chapter.

I once had a college mentor who was a campus administrator, and she would often mentor students across all academic levels. One thing I initially noticed was that many of the students who were receiving mentorship from her would have so much turmoil in their personal relationships with other mentees. Of course, I ignored that sign and brushed it off. It wasn't until I actually developed a mentor-mentee relationship with her that I found myself in the same

situation as previous mentees, having constant disagreements and drama with fellow mentees who I worked with as a campus leader. This was daunting to me because I've never been the type to find myself within the realm of constant drama. I'm an introvert by nature, so drama isn't one of my hobbies. At that moment, I noticed exactly what it was: this mentor didn't have the heart or intentionality for mentoring. She only had the professional experience that many were impressed by. I watched her purposely cause division within her mentees that had working relationships together.

I know it sounds far-fetched, but I'm telling you that I've never seen anything like it before in my entire life. I honestly thought I was tripping when I finally put the pieces together. I felt as if I had solved a puzzle that came with a million pieces in the box or as if I had solved a crime. After I watched the mentor a little more closely, I saw her play both sides in simple mentee-mentee disagreements that soon blew up after she pit some of the mentees against each other.

Soon after my realization, I brought my findings to other mentees, and I just knew they would disagree with me and probably even get upset and try to say my accusations were false. Yet, much to my surprise, they responded that they, too, had figured it out, and they were just waiting on me to have my enlightened moment. That enlightenment felt as if someone had drove a knife through my back and plunged it into my heart. It was a betrayal, but it was also another opportunity to learn more about people and how there are times when people will say one thing and intentionally do another. However, life happens, and it was better to have had that experience earlier on in my life rather than later.

Dismantling that counterfeit mentor relationship was no easy feat, but it was necessary. I didn't bad mouth my former mentor, and I actually handled the situation with poise and grace. I couldn't believe that this family-like figure had been allowing negativity to ferment in these relationships, and as a mentor, she just sat back and purposely attempted to heighten the separation between mentees who once had close family-like relationships.

This book is the first time that I've even publicly acknowledged that experience. I made sure to heal from it so that I didn't block out any future mentors just because I ran into a false mentor who lacked the heart and intentions to be effective. I'm a firm believer that a counterfeit comes before the real deal, and the real mentor surely did arrive soon after. Once my legitimate mentor, Chequita, arrived, I was able to actually discern that Chequita's heart, intentions, and experience were all in the right place!

## Experienced Leaders

Even outside of mentorship, the qualities of heart, intention, and experience are all just as important to be an effective leader. Like mentorship, having the experience but not the heart or intention can be detrimental to leadership, especially in business. Trust, I've seen it firsthand in the restaurant industry with one business owner.

There is a restaurant on the North Side of Chicago, Batter and Berries, that is known for its delectable flavors of French toast and its all-around exotic menu items. The place is so popular that it's perfectly normal to have to wait at least an hour to get seated. But, the head chef at the restaurant left, took his "world-

renowned" menu with him, and opened a similar type of eatery on the South Side with pretty much the exact menu from the other restaurant. The perk for customers was that they could now get their favorite food on the South Side and not have to drive almost an hour to the North Side past downtown Chicago just to fight for parking and wait at least an hour to be seated.

It was clear that this new place was competition to the North Side location until one day I decided to look up the Google reviews for the South Side location. Of course, with any food place, some customers will be satisfied with their experience while others will not. Well, the owner of the restaurant wasn't pleased with any of the customers who left anything close to a negative review. Some customers mentioned that their food may have been cold when brought out by the server, or a few mentioned that they waited a lengthy time to get seated when they visited around popular holidays. These are things that can and have happened at many popular establishments. However, the manager took the time and refuted every, and I mean every, negative comment. It got so bad that the manager cursed out some of the patrons in his responses, calling them out of their names, using offensive slurs, and informing the customers to go to another restaurant if their experience was so bad.

Clearly, the manager may have had good intentions for opening a restaurant that would serve and provide delectable meals with good service, but the heart and leadership experience were missing. Having the heart for leadership would have provided him with a clear understanding of how to properly respond to unhappy patrons, especially since these responses were publicly documented for potential customers, employees, and investors to see. Having experience would

have allowed the manager to understand that businesses run because of the experience of customers who not only return to a restaurant but who also share their positive experiences by word of mouth.

The combination of heart, intentions, and experience go beyond mentorship and extend to places and opportunities that require effective leadership, including starting a new business or pursuing your passions. Positive mentoring is founded in the understanding that it is perfectly fine for mentees to surpass the accomplishments of their mentor, and effective leaders know that their connections to the community is what helps them thrive. There's a clear difference between a mentor or leader who has the heart, experience, or intention to serve in their position and one who doesn't.

# Innerview Questions

Have you ever had an experience with a counterfeit mentor?

What mentor have you encountered that has the heart, intention, and experience for authentic mentorship?

# Even the Big Homie Can Be Wrong

"Not all leaders are leading their groups to worthwhile, sustainable territory where they can make positive, life-affirming decisions."

After learning about counterfeit mentorship from direct experience, I had to watch a few others experience their own version of counterfeit mentorship in their lives. In 2018 after I left corporate and moved back home to Chicago, I had the privilege of going back to my high school, Percy L. Julian, and working with the students in a college preparation program that focused on leadership and professional development. Julian High School is on the South Side of Chicago in a neighborhood known as the Wild 100's. The fast-paced nature of the neighborhood can be intimidating to outsiders. However, I was excited to work at the school because it gave me an opportunity to give back directly to the community and place that helped make me who I am. Much to my surprise, the teenagers were full of energy and addicted to social media, and they were in that awkward phase of life where you aren't an adult, but you're no longer a little kid.

One day, I was working with a group of juniors to review information on tuition costs and scholarships when a tall male student walked into the room talking loudly with a hostile tone toward another male student in the class. He told the other student that he was his "opp" (opponent) and to not ride in his hood anymore playing loud music. Before I knew it, I immediately went into Momma Mode and diffused the situation before it turned into anything major. The last thing I wanted was to have these two students fighting in my class.

I pulled the tall student to the side and immediately asked him for his name. He told me his name was Sean (the name has been changed to protect the student's identity), and I told him that I was disappointed to hear him use such language in my presence. I asked Sean if he owned every house on the block that he referred to as his hood or if he had a mortgage to pay on all those homes. Of course, I had to ask if he even owned the paved streets in his neighborhood. He immediately laughed because he could see where I was going with my questions. He knew I was joking but serious at the same time.

Before I knew it, Sean started talking to me about his athletic involvement at the school. He shared that he was a star athlete in multiple sports, but he was conflicted because he also had another life in the streets. We talked about him playing college basketball, but of course that meant he had to be intentional with his leadership around school and stay out of any trouble, especially if it could lead to legal trouble. His eyes lit up when he talked about his future aspirations, and I knew it was my job to let him know that it was possible.

During the summer of 2018, I also worked with a select group of students in a summer program at Julian High School called Peacemakers, which aimed at

promoting peace in violence-prone communities. Sean happened to be in the program, and my eyes lit up when I saw him. I knew that him being in the program gave me more time to have conversations with him about his bright future. Sean came in one day, and it was clear that he was upset and flustered. When I asked him what was wrong, he blew me off and dismissed my question. I stepped back, both figuratively and literally, and gave him his space. At the end of the day, Sean came over and apologized for how he handled the situation and mentioned that he meant no disrespect in his earlier response. Sean and I sat and talked, and surprisingly, he opened up to me about his life. He shared that he had lost his brother to gun violence some time ago and that the situation was still impacting his life. Not only was he dealing with his brother's death, but he was also dealing with how uncomfortable he was with his own street life. No matter how much Sean tried to glorify himself as a "street dude," he was secretly afraid of ending up like so many of those around him who were living the same life. During our conversation, I asked him about his introduction to the street life because I was confident that he didn't just wake up one day as a kid and win a street membership from a cereal box.

The more we talked, the more I noticed that Sean kept mentioning his "Big Homie." Sean almost glorified his Big Homie, which intrigued me and made me want to learn more about this leader who my student idolized. As Sean started to go into the details of his relationship with this male leader, it was clear to me that the Big Homie was leading Sean down the wrong path. Sean was looking for a role model, but instead, he found comfort in a counterfeit.

No matter how much life, poverty, violence, or environmental factors may have aided in Sean's process of maturing, it was clear that he lacked the necessary social-emotional skills and wisdom to be able to recognize that his Big Homie was a false leader. For the remainder of the program, I concentrated on showing Sean opportunities that would help take him away from his street life and open safe doors of opportunity for him. By the end of the summer program, I'm sure Sean was probably tired of hearing me ask him how he was doing or always telling him how far he was going to go. But I also know that he respected me for never judging him, and he realized that he had someone in his corner in addition to his family. After the program ended, Sean set his sights on attending college for athletics, and I pray not only for his safety, but also for his ability to make smart decisions that will allow him to make all of his dreams come true.

Sean isn't the only one who's looked up and realized that he was being misled by someone who was also misled. Think of it this way: how many times have you been on the prowl for a particular connection only to be met with a counterfeit who you surely settled for? How often do you take an inventory of the life or situational outcomes of those who are under a common leader? Simply put, how often do you pay close attention to see how much or how little some have achieved under the mentorship of a particular person? No matter how much Sean looked up to his Big Homie, he knew that the Big Homie was wrong and leading him astray. Not all leaders are leading their groups to worthwhile, sustainable territory where they can make positive, life-affirming decisions.

# Innerview Questions

What steps do you take to decide if a prospective mentor has what it takes to play a role in your success?

What advice would you give to those who desire to be a mentor?

# Don't Die, Especially in the Winter

---

"The same sun that goes down at night and causes darkness is the same sun that will rise again in the morning and bring light."

Yes, we will all physically die one day; it's inescapable. We can't talk or pay our way of it. If life has taught me anything, it's that life is truly just a vapor. We can be in the land of the living one second and pass away the next. With the fragility of life, it's imperative and almost mandatory that we don't die with our gifts remaining dormant within us. It's also key to know when some struggles are just temporary so that we don't make permanent, life-altering decisions on a temporary experience. What gifts and talents do you have? What actions can you take to bring those skills to the forefront? In what way has fear put a damper on you moving forward with your purpose?

Whenever I drive past a cemetery, I often wonder how many unwritten/unfinished books, unspoken words, and regrets live there. When I talk to people who are older than me, I ask them what are some things that they would

like to do at this point in their lives. Many times, the conversation turns into them reciting memories of their past regrets, of things they wished they would have done. Too often, they feel as if it is too late to even begin to take action on some abandoned goals, whether it was going back to school, starting a fitness journey, or taking some me time. These conversations would break my heart almost every time. It's never too late to be the person who we were called to be, even if we have to make some life changes to accommodate the calling and bring our joy and happiness to fruition. It can be as simple as learning a new hobby that you've always wanted to try, or if you want to be an avid book reader, it can be as simple as getting up 30 minutes or one hour early to dive into a new book or deciding to read a new book every month. We have to intentionally make time to bring our dormant talents and goals to life.

Before getting knee-deep into the writing process, I promised myself that I would pour out my all into this book, and I refuse to die with it in me; I refuse to knowingly have these gifts and talents and not be a good steward over what I was given. This book is full of lessons learned from my on-the-job training at the Fortune 500 Corporation of Life, and I knew it was time to allow these words and stories to flow authentically from my heart. It was a knowing and a feeling that pushed me to write this book. I became protective of the unfinished book because I could sense the value that it would provide to myself and others.

I then did what any writer would do; I set the atmosphere during my designated writing time. I walked around my house talking out various key lessons that I've experienced. I even bought a white dry-erase board so I could write out any ideas that came to mind. If an idea came to my mind at 2am, I gladly hopped

out of the bed, pajamas and scarf still on, and covered my board with ideas that soon turned into book chapters. I also assembled a team of people I trusted and asked them to serve as my accountability partners and on my board of directors to make sure that I didn't allow fear to stop me from reaching a goal that was, without a shadow of a doubt, part of the person I was called to be. I even covered my room and bathroom mirror with words of affirmation to push me forward whenever I found myself losing the motivation to finish writing.

---

There's wisdom that comes with not dying in the winter, during our toughest times. Of course, death can come when we least expect or want it to, but dying in the winter is the equivalent of giving up because of a challenge in life that seemed too hard to overcome. Pushing through a difficulty allows us the opportunity to look back on a tough time and reminisce, sometimes with laughter, on how we made it through. Being a servant leader and pursing a calling doesn't exempt one from tough times or from finding oneself in a harsh winter season. I found that out firsthand as I watched parts of my professional life soar while taking a hit to my personal life.

Like most young adults, I went through a breakup at one point in my life. Let me preface this story by revealing that I can now look back on the relationship, smile, and even crack jokes with friends about that breakup. While living in Bloomington, I was dating a guy who lived quite a ways away from me. Despite the distance, it was blossoming into a relationship. Even though I started to see

clear signs that things needed to end, I wrongfully shrugged off those signs and continued to build a romantic relationship with this guy. Nevertheless, it ended in November.

Chequita, my authentic mentor, was present in my life during that time, and she helped me get over it by reassuring me that the sky wasn't falling, and life didn't stop just because the relationship ended. Immediately after what can be described as a breakup, I had got so stressed out at work one Fall day that I figured I would get up from my desk and take a walk around the floor. Our building and workspace were pretty much a huge square, so walking around the entire floor would place me right back at my desk. Once I got up and started walking, my mind started racing, and it zeroed in on the thought that ending the relationship meant that I was losing a friend too. With each step I took further away from my desk, the more my thoughts started going like rapid fire. Then it happened. I felt like I couldn't breathe, and I immediately needed to find a chair to sit in. My heart was racing, and I began to panic because I wasn't quite sure what was going on with me physically.

Unbeknownst to me, this was the onset of a panic attack, which wasn't the norm for me. I knew that I had about 30 seconds to get it together before a colleague walked past and would rush to call an ambulance. I talked myself through the process of calming down and trying to breathe regularly. I got my breathing under control and then I immediately sent Chequita a text saying that I needed to drop by her house after work. She could tell something was wrong because I would normally ask if she was busy after work. I never just barged my way into her

schedule, but this time it was critical. I needed to talk through the situation, and I needed to know that I could get through it.

After work, I went straight to Chequita's house and fell apart like shattered glass, and she was right there to listen. She let me know that I would be fine, and that I was just grieving my expectations for a person and a relationship that no longer served a purpose in my life. I had to reevaluate the space I was allowing the situation to take up in my life and my mind. I sat on her couch and wanted to hear nothing more than, "Nat, you're going to be okay." In addition to hearing those words, she told me that I was in a winter season, and I would be foolish to think that this was a permanent tragedy. She assured me that life would go on.

About a year later, almost to the exact date, we laughed at how I sat on her couch looking as if I was in a trance and how she could almost see the pain in my face. We didn't laugh because we thought that time period was comical; we laughed because I had learned a lesson that we often learn in elementary school: "The sun will shine again." The same sun that goes down at night and causes darkness is the same sun that will rise again in the morning and bring light. Nevertheless, at the time, the breakup made me feel like the sky was falling.

Around that same time, I went to a dinner with the women's ministry after church one day, and although I was surrounded by people, I zoned out completely and wanted nothing more than to crawl under the table across the room. It felt as if someone had ripped my heart out of my chest, and I was more insulted that I still had to do daily tasks as if I wasn't feeling like shattered glass. I wanted to take a few days and grieve what felt like a death. I wish I was exaggerating. If we're talking about not dying in our winter season, then I wasn't sure if I would make it

because that winter felt like 100 degrees below Fahrenheit with lake effect. I admit that I allowed that one situation to completely take over my mind, and the mental stress was showcasing itself in physical ways.

That same November, I was booked to speak every weekend, and I wanted to cancel every engagement so I could just sulk. But I knew I couldn't cancel my leadership responsibilities just because the personal side of my life was in shambles in that moment. I had no idea that pushing through my strife would mean that I would find healing and encouragement in the audience at one of my speaking engagements. I traveled to the University of Missouri-Kansas City (UMKC), and I did a talk on sisterhood. The energy and love in the room was just what I needed as double confirmation that the sky wasn't falling and that I would get past the heartache. I met some of the most amazing students who were transparent and vulnerable when explaining what sisterhood meant to them. In that moment, I had to rhetorically answer my own questions and examine what sisterhood meant to me. I was thankful for the women in my circle; regardless if things in my life are nearly perfect or in mere shambles, they are present and ready to lend a helping hand. Boy did I get over the breakup quick after presenting at UMKC. This breakup and the tough winter I went through because of it helped me to realize that leadership isn't always about us; it's about the lives that we can touch and the blessing we receive in knowing that our impact is legitimate.

In my moments of reflection, I often think about the amount of people who died in their winter, who didn't believe they would ever see the sun again. Your winter can be any situation outside of a breakup, including the loss of a job, moving to a new state without your support system, financial difficulties, or even

an accident that required some form of surgery. One way or another, life happens to all of us, but winter isn't meant to last all year; it's called a season for a reason. We have to push pass difficulties in order to push out the gifts that are living inside of us.

# Innerview Questions

Which tough time from your life represents your winter?

What lessons did you learn from your toughest winter?

# Love Lyfts Us Up

---

"What was supposed to be a quick and quiet Lyft ride turned
into a wisdom-filled ride full of motherly advice and
heavenly conversation that became forever etched on my
heart."

Having access to Lyft and Uber are just two perks of living in a major city, especially Chicago. These ride-sharing services have transformed public transportation and provided people with options other than catching cabs or riding the bus. These infamous apps have also connected people from across the world with the swipe of a smartphone. Drivers and riders are able to share thought-provoking conversations, words of wisdom, and even networking opportunities in the time it takes to get from one side of town to the next.

I'll never forget a Lyft ride that I took from Downtown Chicago to Bronzeville, IL. Parking in downtown Chicago is unfairly expensive, and Bronzeville is about 15 minutes away with good free parking. So, I learned the trick of parking in Bronzeville and then getting an Uber the rest of the way to downtown. Even if the cost of parking and getting an Uber from Bronzeville were similar to just parking downtown, I would still get a ride because I would have one

less worry by not having to find a parking spot downtown. That day, I had a meeting downtown that ended early, and I did something that I rarely did: I used the Lyft app instead of Uber. My driver was a brown-skinned woman with ear-length natural hair styled in a twist-out. As I got into the car, I jokingly thought to myself, "This car smells heavenly," essentially because she had some really fragrant scents in the vents that smelled like mint.

My introversion normally kicks in when I catch a Lyft or an Uber ride, and I always hope and pray that I get drivers who don't mind riding in silence for the majority of the trip besides the courtesy of an initial hello and a thank you once we reach the destination. The moment I sat down, she immediately asked me how my day was going and about my background. I thought to myself, "This woman reminds me a lot of my mom," but I shrugged it off and kept engaging in conversation. I mentioned that I would be starting my PhD program soon, and that in a few weeks, I would be moving out of state. She mentioned that she and her husband had been married for almost 25 years and that their third daughter was off to college, leaving them to be empty nesters.

Since she talked about her marriage, I asked if she and her husband still like each other beyond the love and how they were able to stay happily married for so long. She laughed and said that she's still very much in love with her husband after all those years, mostly due to their intentional communication. She went on to say that they attend marital counseling frequently just to make sure that they were providing their marriage with the attention and counsel it needed in order to stay intact. She revealed that many of the marriages in her family that she grew up watching were either unhealthy, didn't last, or some combination of both. But she

was intentional about not bringing family baggage into her marriage without being aware of the things she figuratively carried over with her. She walked in her journey of wholeness to be the best mom and wife that she could be. The conversation wasn't just the driver spewing out her business; it was her pouring her wisdom into my spirit.

The more she shared, the more I started to get chills. This woman was almost an exact replica of my mom. Her spirit, voice, and skin complexion made me feel as if my mom was my Lyft driver. My heart started racing, and I felt like I was seeing a ghost the more she talked. All I could think to myself was that there was no way that was happening, and people would think I was tripping when I retold the story. By the time we made it to where my car was parked in Bronzeville, I was weeping in the backseat of this woman's car. This was an ugly cry from my soul. The kind like when you would get a whooping from your parent, and your cry turned to hyperventilation. I wasn't the least bit ashamed because it was such a moment of humanity and emotional expression. It was a release that I needed more than I even knew.

I apologized and told her how much she reminded me of my mom, who had been deceased for 12 years at that point. She turned around and assured me that there was no need to apologize, and she understood because she, too, had lost her mom. She said that our conversation was God's way of providing us with assurance that although our moms were no longer here physically, their spirits lived on, and we get opportunities to feel the warmth of their presence. What was supposed to be a quick and quiet Lyft ride to my car turned into a wisdom-filled

ride full of motherly advice and heavenly conversation that became forever etched on my heart.

The wisdom that we acquire isn't meant for us to hold bottled-up to ourselves. It's about spreading what we've learned and sharing those lessons that have come as a result of success or failure. Leadership doesn't have to be a long-drawn-out speech with wagging fingers. Instead, it's those moments of people coming in and touching our hearts through the sharing of their experiences. I'm not just learning this; I'm implementing it each step I walk in purpose.

Recently, I served as a speaker for multiple sessions at Mizzou's TRIO program orientation for freshman and as a keynote speaker for a large fall semester event. During the negotiation phase of finalizing my contract for the speaking engagement, I considered not speaking at the event because there were a few issues with the contract details. After reflecting on that Lyft ride, I realized that I should take the event because I knew that I had some wisdom to pass on to the students, and in this case, I wasn't going to let the negotiation hiccups be a barrier.

I arrived at the first event early to set up and let my normal speaking jitters calm down. Much to my surprise, one of the TRIO students arrived at the event early too. Of course, she and I weren't just going to sit awkwardly in the room and not talk to each other. I introduced myself, and she said that her name was Jasmine (the name has been changed to protect the student's identity). We talked about her thoughts of campus and college so far, since she was a freshman during her first few days on campus. The conversation went well, and I was so impressed by not only her maturity, but also the goals she had for herself to use her campus experience to prepare for law school.

About two weeks later, I keynoted a larger Mizzou TRIO event on leadership with all of the university's TRIO students, not just incoming freshmen. I talked about using campus leadership to prepare for life beyond campus, and I mentioned my group of friends, the Golden Girls. One of the Golden Girls, LaShawnda, was actually there to hear me speak. After the presentation, Jasmine came up to me, and I immediately called Jasmine by her name and complimented her on how her curly natural hair was gorgeous in the style she was wearing. She laughed, said thanks, and gushed about how she couldn't believe that I remembered her. I enjoy engaging with people, and I pride myself on showing my humanity through my work, especially by showing people that I am engaged during conversation and I can recall details.

A few days after the event, Jasmine sent me a message on social media saying that she enjoyed my keynote, and it meant a lot to her that I remembered her name and engaged in such a personable conversation afterward. Jasmine said that she wanted to reach out initially after my earlier TRIO presentation with the incoming freshmen, but she was afraid to do so until we chatted after my larger keynote a few weeks later. She revealed that campus life was becoming a bit much for her, and she was finding herself feeling lost on such a huge campus with so many people. She asked if she and I could meet up on campus soon and just chat. I jumped at the chance to meet up with Jasmine and pour into her as a mentor. We were able to meet up multiple times, and we eventually developed a big sister/little sister relationship where I was able to be transparent about my life as a means of providing her with direction and wisdom. What I didn't expect was for Jasmine's father to pass away two months after she and I connected.

When she told me the news about her dad, I immediately prayed for her and her family. I also prayed and asked God to give me the words and actions to ensure that she felt supported. It was at the end of the fall semester shortly before finals week when her father passed, so I asked if she had eaten and offered to take her to grab some dinner. She was open for dinner, and I made sure that we had a light-hearted conversation, only talking about her dad at her mentioning. We also talked about our shared faith. Beyond that conversation, I made sure to regularly check up on Jasmine. When Jasmine's mom came to campus to pick her up for winter break, I met her mom and exchanged contact information with her so that she knew that Jasmine had someone on campus to watch out for her. You could see the sigh of relief on her mom's face after that conversation because Jasmine was definitely going to need the added support academically as well as emotionally as she grieved the loss of her father.

Now, if I had allowed the initial issues with the contractual negotiations to stop me from taking the TRIO speaking engagements, I would have missed the opportunity to pour into Jasmine's life and become an authentic mentor to her in one of the most critical moments of her life. Not only was she navigating the new experience of college, but she also had to go through the process of burying and grieving a parent. True leadership must include a love for gaining and sharing wisdom that lifts up others as they climb their own mountain of leadership and purpose. When we step into the roles of leaders and mentors, we have to be committed to examining our heart, experience, and intentions for mentorship.

## Innerview Questions

How often do you have experiences that remind you of a lost loved one?

Whose life have you been able to change through words of wisdom and sharing of your time?

# Some Cycles Aren't Meant to Be Broken

"The cycle of being an authentic mentor and receiving authentic mentorship should be consistent. You learn from others and then others learn from you."

When I hear the word "cyclical," I immediately think of a rat on a wheel, constantly running on a never-ending loop. I imagine the rat running and thinking that it'll eventually get to its desired destination. Cyclical can also equate to negative generational cycles, which are normally trials and struggles that are rampant and constant throughout a family for generations. Those cycles are meant to be broken, destroyed, and banished. However, there are some cycles that are meant to stay in place and keep moving, and one is the cycle of beginning again. Whenever we accomplish and master a great goal, it's customary for us to find another area to master. Starting again in a new area means that we are comfortable with not knowing it all and are willing to start at the bottom and work our way up.

I declare that every time I begin again, I embrace the cycle of watching everything come together perfectly. After leaving my corporate job, I moved home

to Chicago to prepare to begin again in 5 months when I started my doctoral program at the University of Missouri-Columbia. I'm someone who needs to stay occupied and productive at all times, so I was concerned about making sure that my time was well spent. I applied for a job as an adjunct instructor at a college that was a little less than an hour away from Chicago. Although I was offered the position, for some reason, I decided it was meant for me to stay with my then current job working with the college and career team at Julian High School for the duration of the summer. Little did I know, working with the students at Julian would change my life in more ways than I could have imagined.

When preparing to work with students in the summer program Peacemakers, I attended a two-day training that covered workshop facilitation and reviewed the curriculum. I was surrounded by other instructors who would also be teaching at various high schools located throughout Chicago. On the last training for the day, the workshop leaders came into the room and mentioned that Arne Duncan would be stopping in to talk with us. Everyone else looked as if it wasn't a big deal that the former Secretary of Education would come in and impart wisdom on us.

I'm guessing that the other instructors weren't familiar with Arne Duncan or his background with leadership and education. I'll let you in on a little bit of insight on Mr. Duncan. Back when I was in high school, he was over Chicago Public Schools, the third largest school system in the nation. Soon after Barack Obama became president, Arne Duncan was appointed to the presidential cabinet as Secretary of the U.S. Department of Education. Long story short, Arne Duncan was more than a big deal, so being in his presence was the perfect opportunity to

learn more about leadership at one of the highest levels in the nation. His wisdom would help me during my own process of beginning again.

Knowing that Mr. Duncan would be walking in to talk to us in just a few minutes, I immediately went into "learning-and-networking Nat." I wanted to glean and learn from Mr. Duncan's experience and learn more about his background beyond what I would be able to find through a thorough Google search. My brain went into action thinking of questions and how I could stand out, which I knew I would be able to do during the Q&A.

I have to pause here and mention that a month prior to this encounter, I went to lunch with my stepmom. At 25 years old, that lunch was the first time that I had ever been one-on-one with my stepmom to just chat over food. I wisely spent that time learning more about her and her upbringing. During our conversation, she mentioned that she and her siblings grew up with Arne Duncan. Stunned, because Mr. Duncan was someone I had always admired as a leader, I prompted her to go into more details, and I learned of his mom's commitment to provide the community with a safe haven and exposure to opportunities beyond their current socio-economic status.

So, when I was preparing my questions for the Q&A, I knew that I would mention the work his mom did as that wasn't information that one could easily find on the internet. I just knew he would probably be interested in knowing how I was familiar with a time period that I wasn't even alive to see. After Mr. Duncan was done with his presentation, he opened up for the audience to ask questions, and I had started talking myself out of asking the question that I had written down. Fear was starting to set in, but I had to remind myself that I was provided with an

opportunity that could lead to the acquiring of immense wisdom. I pushed past the random fear and executed my impromptu plan. While Mr. Duncan fielded questions, I raised my hand and stood up. I introduced myself and shared some of my knowledge of Mr. Duncan's background. I purposely stood up so that I could display my confidence and show that I took myself and my question seriously. My question included a reference to his mom's community work, but it focused more on the process he uses to discern who has the leadership potential and work ethic to be a vessel for mentorship and the passing of the baton.

Much to my surprise, Mr. Duncan took more than a few seconds to gather his answer. He replied that he looks for not only the work ethic, but also ethics within a person. Lastly, he mentioned that he looks for someone who is ready to work and assemble a diverse team for goal execution. His answer was pretty much confirmation that I was on the right path with my ideas, steps, and visions of leadership. When his time ended, he gathered his stuff and left out with his team. I got out of my seat and followed to personally introduce myself. I shook his hand and told him that I would soon be leaving for graduate school, but I would love to get some time on his schedule to learn more about his leadership experience and perspective. Much to my surprise, he agreed and provided me with his contact information. He also mentioned that he remembered my stepmom and her siblings, and he referred to them by name, which was an indication that he really did remember them.

At another gathering with other instructors across the city, we got the opportunity to have dinner with Mr. Duncan and one of his mentors, an African American leader in the finances. When I walked into the venue, Mr. Duncan

happened to be sitting at the check-in table having a conversation. He looked at me and said, "Hey Natilie! How's everything going? We have a meeting coming up before you leave off for graduate school." I was surprised that he remembered my name and key facts about me.

Months later when he and I had our meeting, it was amazing to get a close-up of his passion and authenticity for helping the local community and in making a difference with African American men on the South Side of Chicago. The conversation provided me with true insight on being an authentic leader. I walked into the meeting with a prearranged list of questions that took forethought, and I left out feeling refreshed and equipped with an additional set of tools of wisdom as I was leaving for graduate school in two days.

There was one piece of the conversation stood out to me, and truly impacted my life and became part of my speaking message. Being part of a presidential cabinet normally involves managing a team and budget with so many zeros that it would make any of us shudder. I asked Mr. Duncan how he ensured that he and his team were acting ethically and with the utmost integrity. His response was simple, powerful, and one that I wasn't expecting. He said that he told his team to make decisions as if it would be on the front of the morning newspaper and then ask themselves if that decision was one of integrity and honor. That requires self-awareness and the ability to be vulnerable enough to understand that our actions impact more than just us.

Our leadership-related decisions should continue the cycle of integrity and great character. That cycle of authentic and trustworthy leadership isn't meant to be broken. Just as Mr. Duncan willingly offered his time and wisdom to me, every

leader should be ready to pass on our leadership expertise to the next generation. The cycle of being an authentic mentor and receiving authentic mentorship should be consistent. You learn from others and then others learn from you.

One Spring semester, I was invited back again to speak and keynote at Central Michigan University. This time, I was a keynote at the Multicultural Student Leadership Conference, and it highlighted the importance of providing mentees with our stories of overcoming. I was honored to have yet another opportunity to pour back into the place that built me up and provided me with the tools and experiences that shaped my life and outlook. I remember being nervous about my keynote on putting legacy in leadership, but I knew that I had valuable lessons to pass out. I gave the presentation my all, and my audience asked detailed questions during our Q&A session. I couldn't believe they got it! They got exactly what I was intending for them to grasp. They understood what it meant to be intentional about passing on leadership skills to those who are coming up behind, passing on the baton of campus leadership.

After the presentation ended, I stayed around and talked with other audience members and answered questions. My heart was so full because I was sharing my knowledge and leadership expertise with the next generation. When I got back to my hotel room, I saw that I had received multiple messages on social media, but there was one that stood out. This young lady sent a request for mentorship, and she provided claims as to how my mentorship would be beneficial to her. I, of course, sent her my contact information. She reached out to me, and we chatted about her future life goals and personal aspirations. Eventually, she

became like a little sister to me, and before I knew it, I was becoming the same person that my mentors were for me.

My mentors have always been a safe place for me to ramble on about my goals and be transparent about my failures and fears. I've gotten over many hurdles and broken down plenty of barriers, many of which I was responsible for building, all because of authentic mentors who poured into me. It means the world for me to be able to provide authentic mentorship and leadership for others as many have continued to do for me. I'm committed to maintaining a healthy and cyclical form of leadership that empowers others to do the same.

# Innerview Questions

Whose story of leadership would you like to learn more about in an one-on-one conversation?

In what instances have you been able to learn from those who you once admired?

# A Return to Say Thank You

---

*"Ten years later, in 2020, I happened to run into Mr. Smith and provide more than a simple thank you; I was also able to show him the progress I was able to make because of his family's investment in my education."*

Thank you. It's a short phrase that has enough power to reaffirm someone's decision to make an investment in the lives of others. As a kid, my mom taught me to always say please and thank you, and she always made sure that I said thank you whenever someone did something for me. Of course as a kid, you often think that your parents are exaggerating when they are passing on knowledge. It wasn't until I was an adult that I realized that my mom passed along enough wisdom to last me a lifetime, and I'm still living on the wisdom and lessons she taught me. Thank you is just one way to let someone know you appreciate what they've done for you and the impact they've had on your life, whether big or small.

My life of leadership is filled with full-circle moments, and there was one specific moment that showed me the power of a thank you. If you remember from a previous chapter, "The Marathon Continues," I mentioned that I received a scholarship from The Lovie and MaryAnne Smith Foundation in 2010 when I was

a senior in high school. Ten years later, in 2020, I happened to run into Mr. Smith, and I was also able to say thank you and show him the progress I was able to make because of his family's investment in my education.

A few months ago, I presented my doctoral research at a graduate student conference at the University of Illinois Urbana-Champaign, which was on a research study on cross-gender friendships between Black men and women that consider each other to be like family. This study was inspired by my family-like relationship with one of my closest friends from high school, Brian. For the conference, I drove four hours down to the Champaign, IL, and stayed with my mentor Chequita since she lived near the university. After presenting my research, I had plans to grab lunch with a new friend of mine, Tasha, who lived there in town. Tasha and I had met a year prior when I attended a Black women's brunch hosted by her organization, Pedestal Project.

I came across the Pedestal Project organization when I was purchasing tickets for a speaking-related conference for campus professionals. The site where I purchased the conference tickets happened to show a list of upcoming events that were taking place in the same area. I clicked on the details of the Pedestal Project brunch to read some information on the organization, and I fell in love with their mission. Tasha's organization serves to empower Black women to recognize their strength, beauty, and the power of collective Black sisterhood. Around the time of the brunch, I had a dentist appointment scheduled a day prior in the town next to Champaign, IL, where the brunch was being held. It was a no-brainer that I was going to attend the event.

The brunch was such a warm environment filled with Black women learning about the importance of emotional wholeness, spirituality, and taking intentional breaks on the path of success. Everything that I needed to hear and learn was reiterated at the brunch. After the event, I connected with Tasha and let her know how grateful I was for her event, and she and I laughed at what lead me to finding out about her organization and the brunch. After the event, she and I followed each other on social media and agreed to stay in contact and grab food the next time I was in in Champaign. Well, attending the graduate student research conference put me back in Champaign, so Tasha and I made plans to grab dinner right after my presentation. A few hours before our scheduled dinner, Tasha reached out to let me know that she accidentally double-booked herself, and she asked if we could change our plans and just do lunch the following day. I agreed to go along with the change.

The morning that we were scheduled to do lunch, she let me know that the original restaurant that she had in mind was booked, and there were no available reservations at that place. She made a last-minute pivot and made reservations at another place instead. I arrived at the second-choice restaurant before Tasha, and the staff initially provided us with a table by the door until I asked if we could be seated somewhere else. The staff then provided us with a booth across the room. When Tasha arrived, she came over to the booth and sat down, then she and I had a chance to catch up; our conversation was so empowering and was confirmation once again that I was walking in my purpose of touching lives.

As I was eating my food, I happened to look up and see a group of about 10-12 men, many wearing university apparel, walking out of a private event room of the restaurant. As someone from Chicago, I knew that University of Illinois Urbana-Champaign was a Division 1 school, so I was pretty sure that it was an athletic recruiting event. Also, some of the men were really tall, so that added to my assumption that the private room was occupied by athletes. As I watched more of the men exit the private room to leave the restaurant, I spotted someone I knew walking out of the room as well: Lovie Smith. Mr. Smith is a football phenom who went on to be the head coach of the Chicago Bears, and he is now the head coach of the football team for the University of Illinois Urbana-Champaign.

When I fully realized it was him, I couldn't believe he was there in the restaurant. When he walked past our table, I jumped up from my seat yelling, "Mr. Smith, Mr. Smith!!" He turned around, and I immediately introduced myself as one of his scholarship recipients from 2010. I mentioned that because of his family's investment in my education, I was able to not only attend CMU for my bachelor's degree, but I was also able to continue on my education to where I was now, currently working on my PhD. His face lit up, and he let me know that he remembered exactly who I was. Mr. Smith's son happened to be in the athletics group too, and Mr. Smith called him over to let his son know that I was one of the scholarship recipients. At that moment, both Mr. Smith and his son were clearly proud of how far I was able to take my education beyond a bachelor's degree.

Soon after the conversation, Mr. Smith and I exchanged contact information and agreed that I would come back to Champaign to reconvene with him and his family. Mr. Smith made sure to let me know that his wife would be

beyond happy to hear the news of my progress. I went back to my table and gushed about the details when Tasha asked how I knew Mr. Smith. Even after the lunch with Tasha, I basked in knowing that the encounter with Mr. Smith wasn't just happenstance. Originally, Tasha and I were scheduled for dinner, not lunch, at another restaurant. And the only reason I was able to see Mr. Smith walking out of the restaurant's private room was because of where Tasha and I were sitting, which wasn't originally designated for us. Had we been sitting close to the door, there was no guarantee that I would've even noticed Mr. Smith and his team as they were leaving the restaurant.

As I grow in my faith, I often think about how certain biblical scriptures and parables correlate with many of the life lessons and leadership experiences that I've had. As I reflect on my encounter with Mr. Lovie Smith and his family, I think of a passage in the bible (Luke 17:11-19) when Jesus healed ten lepers and then sent them home to showcase the healing awarded to them. Before they returned home, one of the ten lepers turned around to say thank you to Jesus. Ten of the lepers received healing, but only one of them said thank you. For the one who said thank you, Jesus declared that the one leper received a wholeness beyond his healing because he was able to say thank you to the one who healed him.

I promise that my life events are no coincidence and every experience has been the key to me growing and learning as a leader through the gracious pouring into my life by others. In no way am I saying that Mr. Smith is Jesus nor I have ever suffered from leprosy. However, what I am saying is that there's an added level of gratitude you can display when you slowdown and stop to verbalize gratitude and showcase your thankfulness.

That chance encounter with Lovie Smith just shows that thank you is not only a powerful word to those that have imparted wisdom and action in our lives, but it also provides the giver with evidence of their own effectiveness. When you are doing great and impactful work as a leader, you can't always see the immediate impact. You may plant a leadership seed in someone's life, but there's no guarantee that you'll be physically present to see the seed take root and blossom. It's a moment worth cherishing when leaders are able to see the fruits of their labor grow from seeds to flourishing plants because of some leaders who had the heart, experience, and intention to make an impact on their community.

# Innerview Questions

How do you typically gauge the effectiveness of you serving as a mentor?

When have you been able to witness the long-term benefits of you pouring into the life of someone?

# No Is a Complete Sentence

"One of my mom's oldest sisters, my aunt Dee Dee, taught me at a young age that you can confirm your adulthood when you can say 'No' and not lose a step."

N o. N-O. It's one of the shortest words in the English language, and if you put a period behind the word, it becomes a complete sentence. There's no need for a comma and excuses or qualifiers to follow it. Sometimes simply saying no feels like we're saying a word that should never leave our mouths alone, but it's necessary. I feel so empowered when I can find my voice to simply say no and mean it.

One summer weekend, I went for the second time to Woman Evolve, a Christian women's conference. The conference was nothing short of amazing. Women from all across the world came together in one place to not only praise and worship God together but also to pull on the wisdom of the featured speakers who spoke on the topics of relationships, skin care, business, prayer, fashion, and purpose. I went to the conference for the second year in a row with one of the Golden Girls, Ari, and just like the year before, we shared a double-bed hotel

room. The last night of the conference left us physically drained from the worship service that closed out the conference. We headed back to our hotel, and I knew then that I would have the most difficult time getting up at almost 4:30am to catch a flight that boarded at 6:45am. Keeping in mind that we also had to fill up the gas tank of the rental car and drop it off before we even made it to the airport.

As I expected, on the morning that we were scheduled to fly home, I woke up beyond drained and didn't get out the bed until 5am. Even though I was pushing it for time, I was confident that I would still make my flight because in all my years of flying, up until that point, I had never missed a flight. Ari was ready to pull me out of my bed because she could tell that I wasn't going to get up in time. I was drained and wanted to sleep in at my own expense. Ari's flight was leaving about an hour later than mine, so me oversleeping wouldn't impact her flight at all. By the time we filled up the rental car with gas and dropped the car off, I started to get a bit nervous because it was 5:30am when I got to the airport, and I was met with a huge surprise. The line to check my bag was long, and there were only two airline agents available to help customers. There had to be at least 25 people in the line ahead of me. After checking my bags, I headed over to the TSA security line, which was longer than anything I had ever seen. The line was literally down and wrapped around. At that point, I had no confidence in making my flight. I made a friend in line who had also attended the Woman Evolve conference. While one part of me was invested in the conversation about the excitement and growth we experienced in the conference, the other part was so concerned with my flight that I envisioned the plane pulling away from the gate

while I was nowhere near boarding my plane, let alone on the other side of the security gate.

By the time I made it past security and caught the airport train to my gate, it was already 7:15am, and my flight was long gone. Ari had made her flight back home, but I was still at the Denver airport, and I was ashamed of myself. In all my years of flying, I had finally missed a flight, but I took full responsibility for it. It was my fault; I accepted it and went to the counter to get put on another flight. My flight anxiety, which randomly started back in 2015, makes me uncomfortable with anything other than nonstop flights, so I avoid layovers as much as possible. I need one takeoff and one landing. The airline agent put me on the next nonstop flight, which didn't leave for another six hours. I had no choice but to make myself comfortable at the Denver airport on my six-hour wait.

Fortunately, those six hours flew pass, and it was time to board my new flight. By the time I boarded the plane, I was exhausted. I shuffled into an aisle seat that was right behind the emergency exit, sat down, and introduced myself to the assumed husband and wife next to me. The plane was mostly loaded up when the flight attendant comes by and lets us know that we are sitting in the emergency aisle, and she begins the typical airline warning for those who choose to sit in those seats. Prior to her speaking to us, I was unaware that my seat was considered the emergency exit, and I wanted no parts of sitting there after learning that information. The flight attendant started with a spiel that I remember as, "You are sitting in the emergency exit. Are you willing to open the plane door in case of an emergency on the aircraft? I need a verbal 'Yes' from each of you if you are willing to take on the duties of sitting by the emergency exit." She went around and got

verbal confirmation from everyone sitting on both sides of the emergency exit, then I was the last one that she sought a verbal confirmation from.

I looked the flight attendant in the eyes and simply replied, "No." She was shocked, and I'm sure my answer wasn't at all what she was expecting. But it felt good to say no as a complete sentence. I then asked for another seat on the plane, and she let me know that the only seat available was a middle seat toward the front of the plane. I jumped up and grabbed my belongings, ignoring the eyes piercing through me because I lived my truth. No, I wasn't willing to open the door of the plane in an emergency, and I knew that. I am pretty self-aware, and my uneasiness on plane rides wouldn't mix well with the emergency exit. So, saying, "No," was the best bet. I can handle many panicked situations, but just not those that included airplanes. I knew myself well enough to pass the emergency door seat to someone who didn't mind sitting there. The eyes staring at me meant nothing; I just hoped that they, too, learned to live their truth and let their no mean no. As I moved down the aisle toward the front of the plane, the flight attendant looked at me and said, "Thank you for your honesty." I replied, "My pleasure," with a big grin on my face, which is infamous as a response given by Chick-Fil-A team members. I was being a little facetious when I said it though.

We can't allow ourselves to be guilted into doing what we think will be pleasing to others. One of my mom's older sisters, my auntie Dee Dee, taught me at a young age that you can confirm your adulthood when you can say "No" and not lose a step. Me saying yes to the request of the duties of sitting in the emergency exit could have cost people their lives if an actual emergency happened on that plane. Think of that. Me not knowing how to say no or saying yes only to

please the flight attendant could have caused mayhem. In some cases, us not saying no could have negative repercussions for those around us.

Saying no doesn't make us bad people, but it does reassure us that we know ourselves well enough to know what won't be pleasing or what we don't have the time or willingness to do. Leadership and mentorship, especially when you do those things well, makes you a solution to a lot of people. Who doesn't want to have a walking solution always in their presence? When people recognize the leadership skills that you possess, they are sometimes inclined to take advantage of the resources that you embody. Think of it as if you were managing a team and you knew that one of your team members were always dependable and when that person completed a task, they did the job well with great effectiveness. As a team manager, if you don't have that shining star to train up others to also complete task with high effectiveness, you may be tempted to use that shining star as a constant go-to. Leaders have to make sure that they learn their own weight capacity and build up their ability to say no.

Leaders have to ask themselves, "What is too much for me to bare? At what point do I get overwhelmed?" This level of self-awareness lessens the possibility of you getting overwhelmed by the problems of others. Saying no feels good, and it acts as a barrier against an unfair workload, preying people, and the fear of letting people down. However, it's not just about saying no; it's about being self-aware enough to know the power of your leadership capabilities. We don't always know where leadership will take us in life, but we have to remain sure that we are constantly self-assessing our preparation for new opportunities. We must regularly assess our leadership capacity to make sure that we are ready to learn new

things, treat others with respect, and fight through complacency. Every new dimension of leadership requires even more of us, and we can't give more if we are burned out from people using us up because we don't know how to say no.

# Innerview Questions

When have you said yes instead of no, and what was the impact
on you?

How often do you say no to requests that you are unable to
fulfill?

# Set the Pace for the Race

---

"One implementation of pace and prioritization for one season may not easily transfer over to another season. You have to be prepared to constantly evaluate and adjust your pace based on the demands and priorities of each season of life and leadership that you may find yourself in."

You may think you know where leadership will lead, but you really have no idea what the plentiful end result will be. Leadership will take you places where characters and good manners will help you to stay. It'll also take you to places that you may not think you're ready for. No matter where you are on your journey of leadership, remember to always tell yourself to put one foot in front of the other and never stop walking. Pace yourself, but always have forward motion in your leadership journey that is unshakeable, unmovable, and always consistent. As a simple, yet profound quote from Abraham Lincoln goes, "I walk slowly, but I never walk backward."

Fear is one of the main reasons that we sometimes drag our feet when moving toward making our dreams a reality. Whenever I cracked open my laptop during my earlier stages of writing this book, I would sometimes feel doubtful. I

would think, "Why am I writing this book when there are already millions of books already written?" Immediately, I would cast down all of those daunting thoughts and remind myself of the bread aisle in the grocery store. How often do we travel to the grocery store for bread and see a host of bread companies? These companies have been in business for years because bread comes in different types, shapes, and flavors. And as hard as it may be to believe, there could still be new bread companies just waiting to be created. If the bread analogy isn't enough, just think of the fact that water is bottled and sold even though the same water is available from the faucet in every American home.

There's always a market and avenue for us to pursue our passions and leave our stamp on the world. We just have to be willing and diligent enough to research how we can uniquely insert our niche and begin the takeover, one forward-moving step at a time. But the pace we move at is just as important as the actual moves we make. Leadership and entrepreneurship aren't all about the "we grind while they sleep" mentality because we need sleep just like any human being. Leadership isn't about leading a million teams; it's about leading a few teams well with a pace that allows a leader to be present. We need rest, not just sleep, but actual rest. There is legitimate and scientific evidence that showcases the deadly impact of not slowing down enough to allow our bodies to function in some pace of normalcy.

I wish I could survey every leader in the world and learn about their sleep patterns, their ability to prioritize their work, and the amount of times they say, "No," as a complete sentence. Leadership often requires hours of completing work, leading teams, working on your passion, maintaining relationships, scheduling time for self-care, and making time for sleep. It's a balance that you can

master through proper prioritization, which requires you to decide the level of importance for each task, assignment, and relationship. Keep in mind that these levels can be changed at any time. Mastering prioritization is a process, and I admit that I don't always get it right. It sometimes takes my inner circle of secret service members and board of directors to call me out when I need to fix my prioritization.

Before starting my doctoral program, people would always mention that actively working on a PhD is one of the most difficult things a person can do. When I kept hearing that same line of wisdom, I figured it had to be the truth. There was no way that all these people, many who didn't know each other, were all saying the exact same thing about their experience of getting one the highest academic degrees possible. With this knowledge in hand, I started to wonder about what I was getting myself into by diving into my doctoral program. Well, one thing I knew for sure was that I was jumping into a higher dimension of my purpose. Because of my love for learning, reading, and writing, I knew that I was diving into the one thing that fed my inner geek: academic achievement and the learning process. I knew that with my fellow Golden Girl, LaShawnda, here at Mizzou as well, life would be alright for me!

What I didn't know I was in for was insomnia. Toward the end of my first semester of graduate school, I realized that something was wrong with my body; I wasn't getting rest. I was waking up feeling as if I hadn't gotten any type of rest. At first, I didn't understand why I started to get tired frequently. The exhaustion was hard to understand because I was going to bed, by my standards and those around me, pretty early. However, the appearance of getting adequate hours of

sleep was a mirage. Despite all those hours of sleep, my body still wasn't getting any rest, and my body was trying to alert me to this.

I will never forget being on campus at Mizzou and having to attend a Communication department meeting. That one-hour department meeting felt like it lasted for an eternity. I could barely focus or keep my eyes open. After wrapping up on campus, I went home to my apartment, ate a little bit of food, and went to sleep. That evening, I slept for 12 hours, but I kept waking up throughout the night, which started to be a frequent occurrence. I tried going to bed earlier and earlier, but it was as if the bedtime didn't even matter because I couldn't sleep through the night, no matter how much I tried. It got so bad that by the end of one week, I was exhausted to the point of almost destruction. I was barely getting any sleep, and when I did sleep, I was grinding my teeth in my sleep. Thankfully, that didn't cause any damage to my teeth, but it was an indication that my stress levels weren't normal.

My body felt drained, and the fatigue was pulling on me mentally and physically. I started to notice that my eye was twitching constantly, and although it was unnoticeable to outsiders, I couldn't ignore the subtle movement of my eyelid. Like most people, I did a search on Google and WebMD, and I found that there could be a possible correlation between my fatigue and the eye movement. This was just one additional issue that concerned me about my well-being. I eventually started using a sleep app on my iPhone to track my sleep pattern, and I finally had proof that my theory was right about my lack of rest. The tracker showed that, on average, I was barely getting three hours of deep sleep—scientifically referred to as R.E.M (Rapid Eye Movement) sleep, which is the level

of sleep that allows you to begin dreaming. After learning this, I bought a non-habit-forming sleep aid to help me rest through the night, and it worked. However, I still needed to have a real heart-to-heart with myself in the form of an innerview.

Traveling across the country for speaking engagements, teaching two sections of a college class, and taking my own classes for my doctoral degree was starting to wear on me in clearly physical ways. Though I slowed up a bit with speaking since I had started back school, I still was traveling the country at a rate that was unhealthy given that I hadn't yet learned the pace of doctoral school yet. I had to slow down my work pace for my own sanity and health, especially since I watched my sister fight a similar, more difficult battle a few years ago. Around the time she was finishing up her PhD., it seemed liked she was involved in everything. She was working full time, teaching as a college professor, and maintaining a fully thriving social life, but she started to experience seizures and soon thereafter was diagnosed with epilepsy. She had to start the process of eliminating activities and prioritizing where and how she spent her time. She began to cut down on attending social events, and soon, she learned how to say no. She now takes pride in her ability to say no and to mean it without an apology. As much as the diagnosis was an awakening for our family, it was also a moment of realization for me as well. I, too, had to do a better job of taking care of my own physical and mental well-being, even in the midst of empowering others to take charge of their leadership abilities. I had to take charge of my life but just in a different way.

Prioritization in leadership isn't a one-size-fits-all solution. It's a constant rearranging of expectations based on time consumption and the role we play in getting things done. One implementation of pace and prioritization for one season

may not easily transfer over to another season. You have to be prepared to constantly evaluate and adjust your pace based on the demands and priorities of each season of life and leadership that you find yourself in. Those demands can be present in the personal, professional, mental, and spiritual aspects of your life as leader. The presence of a healthy pace is one way to get to know yourself better. You can only set the right type of pace by asking yourself, "What pace is necessary in order for me to be present and healthy as I fulfill what is required of me in this season?"

# Innerview Questions

What instance of overworking in leadership have you experienced?

What are some signs from your body that you've noticed when overworking?

# Allow Me to Reintroduce Myself

"The power of game changers isn't focused on the length of time associated with their presence; it's the quality of the wisdom they provide that makes them a game changer. They make their time and presence count."

As someone who is growing as a leader and takes the job seriously as I pour into others, I continue to learn more about myself and my purpose. It's as if each step that I take in my purpose, more of my purpose is then revealed to me. Those revelations come from the conversations that I have with advanced scholars, students from my speaking crowd, those who I mentor, and those who mentor me. It's as if purpose is a puzzle and each of those moments equal a puzzle piece that comes together to collectively make up the bigger picture. I can say that for part of my purpose, I have finally figured out that my job is to teach the preamble and then help others teach it to others. The preamble includes the first few lines before the U.S. constitution, and it essentially lays out the importance of what's to come in the constitution. To me, as someone that thinks in analogies and metaphors, the Preamble represents legacy.

Back in the sixth grade at Southwood Middle School, I had an upcoming test on the preamble, and for the life of me, I couldn't remember it, no matter how hard I tried. I remember coming home and telling my mom about the preamble

test that was coming up in a few days, and I admitted that I couldn't quite get the preamble committed to memory and that I was okay with failing the test. Like any endearing mother would do, my mom looked me directly in the face and told me that I had one or two options as it related to the test. Option one was that I could study harder and pass the test, or option two was that I could fail the test and come home to a whooping. Initially, it was a bit of a hard ultimatum because I knew that I had a high tolerance for pain, so the whooping wouldn't hurt as bad as she would think. However, I knew that I didn't want to disappoint her by not passing the test because I wasn't performing to the best of my ability. I excitedly chose option one, which meant that I could pass the test and bypass the whooping.

Instead of leaving all the studying to me, my mom sat me down and went over the preamble with me line by line. After a few hours of she and I going over the study material, I learned to recite the preamble with ease, and my mom's face showed excitement and pride in the fact that I was overcoming what was an initially a roadblock. A few days later, I went to my social studies class and aced the test. My mom's threat of a whooping worked its magic because to this day, I can still recite the preamble word for word. It's forever etched in my heart and in my memory. Years after my mom's passing, reciting the preamble is easy as saying my name or the ABC's.

When I say that I now know that my job is teach others the preamble, I'm not saying that I am going to become a sixth grade social studies teacher. Instead, I'm saying that part of my purpose is to share my wisdom with others through my life lessons and experiences. The preamble represents the years of wisdom that we gain from successes, failures, hardships, and highlights. It is then our duty to pass those lessons on to others. It's the legacy work that doesn't see an end because it continues to spread to others time after time. Teaching the preamble is touching the lives of others in ways that a person can never forget.

Working within my doctoral program has been the perfect meal for me to learn more wisdom as I learn more academically. It's amazing being surrounded by like-minded people who are actively moving toward completing one of the highest academic achievements. One of my favorite classes in my program has been Family Communication for multiple reasons. The professor made the class worthwhile, the discussions were dynamic, and the perspectives were diverse. The class was solidified as my favorite on the day we talked about game changers; that discussion forever shifted my perspective on leadership. A game changer is someone who entered our lives and left a positive mark on it by providing us with confidence, a renewed perspective, and wisdom.

When I think about game changers, it causes me to reflect on my life with this overflowing amount of gratitude because my life has been filled with game changers. My mentors, mentees, community members, and those I've met while traveling across the country have all been game changers in my life. Even the Lyft driver who resembled my mom and gave me jewels of wisdom was a game changer. The Santa Claus look-a-like who helped me during my fitness assessment fits the description as well. My dearest Golden Girls have been game changers through and through. Having the right group of people in your life can allow you to show a certain level of vulnerability that is necessary in times of growth as leaders.

Another game changer is none other than Mr. Johnson. Mr. Johnson is a bank foundation executive, but he's also the faith-filled man who helped shift me into my purpose. Earlier in the book, I mentioned my unbelievable experience with meeting the cast of *A Different World*. Well, Mr. Johnson is the man who made that happen during a time when I didn't even know he existed. After I sent in my letter to the Norfolk State University (NSU) officials who were bringing the cast to NSU, I didn't know that those officials then sent my letter to Mr. Johnson

because his bank was sponsoring the event. He read my letter and was immediately touched by my love for the show, my hard work in my master's thesis, and my tenacity in preserving after losing my mom.

That letter was probably my best written work that year. I poured open my heart in one page of single-spaced text, and the results were tenfold. After receiving my letter, Mr. Johnson reached out to the production staff of the *Steve Harvey* show, and he insisted that they surprise me with meeting the cast. As you know, I met the cast on the *Steve Harvey* show, then went to NSU for the *A Different World* event. After the event, I gained access to the VIP reception. While at the reception, in walked a dark-skinned man wearing a dark blue suit, looking almost as if he and I could be related. He introduced himself to me and asked how the taping of the *Steve Harvey* show went.

You could've knocked me over with a feather because I wasn't sure how he even knew about that. See, before we filmed that segment, I signed a non-disclosure agreement worth $500,000 that pretty much stated that I couldn't release any details on the taping on social media until I was given the okay from the production staff shortly before the episode's air date. I looked at him with my eyes wide from confusion, shock, and a need for understanding. My heart started racing because I was standing there racking my brain trying to figure out how and why this man knew something that wasn't public information. But of course, I played it cool and asked him, "Wait, how did you get that information?" He replied with confidence, "Because I'm the one who set that up for you."

In that moment, I wanted to give him the biggest hug that I could muster, but of course, I kept it professional. I thanked him what felt like 100 times, and I told him that he had no idea what that moment meant to me. I rambled on about how I almost passed out from disbelief, excitement, and pure joy before the taping. All he could do was laugh. But then he did something that he didn't have to do. He started pouring words of wisdom into my life, and I was jotting them down as if they were words from heaven falling from the sky. The one thing that sticks with

me to this day was when he looked me dead in my eyes and said, "This experience with the cast will be the stepping-stone to take you places that you can't even imagine. But in the words of Bishop T.D. Jakes, 'Get ready! Get ready! Get ready!' Mark my words." I caught chills because not only did I feel the power behind his words, but I also discerned the sincerity.

Game changers don't have to be in our lives for 20 years before leaving their mark. The power of game changers isn't focused on the length of time associated with their presence; it's the quality of the wisdom they provide that makes them a game changer. They make their time and presence count. They are people who can see the greatness in you that you can't even see within yourself, and these profound people can activate greatness just by offering a few words of wisdom or encouragement. But it is up to us to receive the gesture and be able to discern the validity and value of their words and acts of kindness.

So, please allow me to reintroduce myself: I am focused on maintaining, cultivating, and elevating my game changer status. The lives of others will never be the same after meeting me. I positively impact each and every audience I speak to. I'm willing to take the journey down the least traveled road of leadership. I am willing to spend the time self-assessing and conducting innerviews to make sure that I am properly equipped with the tools of wisdom and wise counsel. These innerviews have helped me assess my past with a clear view of a future without complacency. No matter the appearance of the situation, I know that fear can't and won't stop me; I refuse to allow fear to do so because I know that greater is on the other side.

From losing my mom and reconnecting with my dad to finding my way in college, thriving in my career as a speaker, and pursuing a PhD, I could have never foreseen any of those things as part of my purpose as an effective leader making impact. In the midst of all these unexpected challenges and achievements, moving forward was my only option. So, while I'm on this journey of fulfilling my purpose and my goals, I won't stop nor give up. Because as Matshona Dhliwayo said, "In

a world full of game players, the only way to set yourself a part is to be a game changer."

Sincerely,

Natilie Williams, a Game Changer

# Innerview Questions

Who has been your game changer thus far?

What mark have they left on your life?